IMAGES
of America

AFRICAN AMERICANS
OF DURHAM COUNTY

IMAGES
of America

AFRICAN AMERICANS
OF DURHAM COUNTY

Andre D. Vann

ARCADIA
PUBLISHING

Published by Arcadia Publishing
Charleston, South Carolina

Library of Congress Control Number: 2016962474

For all general information, please contact Arcadia Publishing:
Telephone 843-853-2070
Fax 843-853-0044
E-mail sales@arcadiapublishing.com
For customer service and orders:
Toll-Free 1-888-313-2665

Visit us on the Internet at www.arcadiapublishing.com

I dedicate this book to two individuals who have widened my understanding and appreciation for Durham: Maggie Poole Bryant, age 102, and in memory of Durham's first African American mayor, Chester Jenkins, my political mentor and friend.

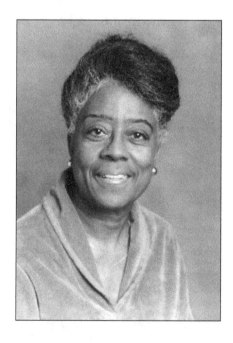

CONTENTS

ACKNOWLEDGMENTS

Anyone who has ever published a book knows that it is a collaborative work and a joint venture of faith and hope until the end. This book has benefited greatly from the cooperation, assistance, wisdom, and generosity of scores of persons. It could not have been completed had it not been for those in the Durham community working and rallying behind the book until its completion. I wish to acknowledge the assistance of Arcadia Publishing/History Press in helping to tell this unique and yet necessary story. I am thankful to have a talented group of individuals such as Liz Gurley to guide the work to fruition.

I am deeply grateful to an entire host of individuals who have gone beyond the call of duty to help me tell this story. I have been supported by colleagues Carter Cue, Kenneth W. Edmonds, Dr. Jerry Gershenhorn, Calvin Reaves, Michael Render, Lynn Richardson, and Dr. Brandon Winford. A special thank-you to Tracey Burns-Vann.

I would like to acknowledge the following individuals who have freely given photographs and treasures from their personal collections: Dr. E. Lavonia I. Allison, Mamie V. Alston, the Honorable William V. "Bill" Bell, Dr. Walter M. Brown, Maggie P. Bryant, the late R.K. Bryant Jr., US congressman G.K. Butterfield, Arthur John Clement, Carter Cue, Martha Grady Dalton, the Honorable Sharon A. Davis, Robert Dawson Jr., the late Andolia O. Eaton, Kenneth W. Edmonds, Dr. William T. Fletcher, Claudette Free, Deborah G. Giles, Iris W. Gilchrist, E. Leon Goldston, Carolyn Grant, and Dr. Paula Harrell.

Dr. Jerry Head, Carolyn Henderson, Leola Jenkins, Dr. Beverly W. Jones, Clara Lawson, Claudine Day Lewis, William "Bill" Lucas, Catherine Burnett Mangum, Marsha Kee, Vivian McCoy, Theodora S. Manley, Kris Mayfield, attorney Eric and Della Michaux, Rep. H.M. "Mickey" and June Michaux, nurse Marion Glenn Miles, Dr. Kimberly Moore, Florida Fisher Parker, Janet E. Young Peeler, Avon Ruffin, John C. "Skeepie" Scarborough III, Judge Karen Bethea Galloway Shields, Gwen Taylor Suitt, James M. Turner, Annie Walton, Warren Wheeler, Andre Carl and Vera Whisenton, Polly Whitted, and Virginia Williams.

Numerous institutions were supportive in providing documentation, including the *Carolina Times*, Durham County Clerk of Courts office, Durham County Register of Deeds office, Durham Historic Photographic Archives, Hayti Heritage Center, the James E. Shepard Memorial Library, John Hope Franklin Research Center, Mechanics and Farmers Bank, North Carolina Mutual Life Insurance, North Carolina State Archives, and the Stanford L. Warren Branch Library.

INTRODUCTION

This pictorial history of African Americans of Durham County is a salute to the role that they have played in the social, political, religious, and economic life of the county. It is a rich, vibrant history of a proud American people. The County of Durham, North Carolina, often called the "Bull City" and the "Chicago of the South," has been impacted and shaped by its African American population over its 135-year history. Here, in our county, the lives, history, and contributions are shown and celebrated year-round. The hope is that this book will chronicle the everyday experiences of African Americans of Durham County as they lived, worked, and played during the Jim Crow era and during the post-desegregation years.

Many African Americans in Durham are descendants of those who lived in the "house of bondage" during the institution of slavery in Orange County, and later in a new township called Durham, and emancipation was slow to come. Long before the smoke could clear, African Americans who were enslaved on the countless plantations throughout what is today Durham County began to move into Durham to work in the tobacco factories and look for better opportunities for themselves, purchasing land, creating families, and establishing churches. In fact, the number of former slaves was so large that they accounted for almost half of the young city's population.

While reconstruction lasted, from 1865 to 1877, it was a short-lived opportunity for mobility and advancement for African Americans who were newly emancipated and in search of equality. Many African American families left the South and moved away in search of better opportunities, to escape Jim Crow, and to unite with other family members. Others remained in Durham. The black codes regulated the types of jobs available and restricted the public spaces where African Americans lived, worked, and played.

Other African American families participated in later mass migrations to other parts of the country in the 20th century and settled in areas such as New York City, Long Island, and Mt. Vernon, New York; Philadelphia and Pittsburgh, Pennsylvania; and Washington, DC, in order to escape Jim Crow and to search for better living conditions and to reunite with other family members. However, other families stayed and learned to live within the confines of segregation and made a way out of no way. It is from this group that a strong and vibrant people flourished and blossomed, and black communities grew. African Americans confronted their status and looked inward into themselves in regards to applying self-help for their communities and promoting uplift for their race. The oldest African American social institution in Durham, as in other cities, was the church. The White Rock Baptist Church, now past its 150th year, dates to 1866, and the St. Joseph African Methodist Episcopal (AME) Church was founded in 1869.

Although Hayti was the residential and social center of African American life, communities such as the West End, East End, Hickstown, Crest Street, Pearsontown, the Bottoms, College View, and others blossomed and grew during segregation and have provided safe spaces for families for generations. Parrish Street, in the center of Durham's white business district, known as "Black Wall Street," became the center of commerce and business and the hub of African American business achievement as the North Carolina Mutual Life Insurance Company and the Mechanics and Farmers Bank were founded here. African Americans throughout Durham were involved in every imaginable vocation. Many were employed as domestics, brick manufacturers, tobacco factory workers, educators, morticians, physicians, and insurance agents. Others operated beauty salons, barbershops, restaurants, law practices, contractor companies, and countless grocery stores.

These businesses provided services and employed countless blacks and helped to create a modest middle class and a thriving working class in the African American community in Durham County. John Merrick, Dr. Aaron M. Moore, Charles C. Spaulding, and Dr. James E. Shepard provided the leadership necessary to sustain the community's economic, social, and political life in the community.

Although the 1950s and 1960s are usually cited as the earliest days of the civil rights movement, it is important to note that as early as the 1930s, residents on Rock Spring Street began to challenge the status quo and ask for paved streets, water, and sewer, and thus became a part of the long civil rights movement. Later, many adhered to the nonviolent teachings of Dr. Martin Luther King Jr. as they sought to challenge the segregated spaces, such as the Royal Ice Cream Parlor, Woolworth's lunch counters, stores, and even the Carolina Theatre, in seeking public accommodations and job opportunities. St. Joseph AME, Union Baptist, and Mt. Gilead Baptist Churches served as gathering spaces for the civil rights movement and helped to nurture young leaders like Ben Ruffin, John Edwards, Vivian McCoy, and Virginia Williams who desired change.

Many tried to live within the confines of segregation by creating uniquely different music that was created by and for African Americans and later would go on to cross racial lines and all geographical barriers. African Americans created music that provided a sense of normalcy and community. Durham native Norfleet Whitted pioneered as a radio announcer for WDNC and was the first African American to broadcast from coast to coast in the United States. In music and the arts, Durham lays claim to such musical greats as Clyde McPhatter, Grady Tate, Shirley Caesar, Blind Boy Fuller, and Gary Davis. It was also the home of such famous artists as Ernie Barnes, Lyda Moore Merrick, and Willie Bigelow, and noted artist and sculptor Elizabeth Catlett began her career at the Hillside Park High School from 1935 to 1938.

This collection of photographs represents self-image and self-representation as it traces the growth and development of a committed people from slavery to freedom who played an important role in every aspect of Durham County. It is hoped that this work will lead to broader discussions and an appreciation of African American life, culture, and neighborhoods. May the next generation of African Americans in the county continue to remember and respect the history and the past of those who came before.

One

THE EARLY YEARS

Margaret "Maggie" Ruffin Faucette (1822–1920), a native of Hillsborough, North Carolina, was among the first of her family members to journey to Durham Station (present-day Durham County) in 1866 after marrying William Faucette. Her children included Jesse Faucette Norwood, Sallie F. Badie, Cornelia F. Mangum, Carolina F. Monroe, Annie Faucette, Beannie Poole Morgan, Nannie G. Cooper, and Thomas, William, and Lindsey N. Faucette. She received very little education but taught herself to read, and the Bible was her favorite book. It was Margaret Faucette who gave the first $1 toward the erection of the new White Rock Baptist Church building. She later lived with her daughter Nannie G. Cooper at 409 Pine Street (present-day Roxboro Street). She is remembered as a woman of high Christian principals who worked tirelessly in the neighborhood and was known to make soup, place it in her basket, and put on her shawl to go visit the sick. (Maggie Poole Bryant.)

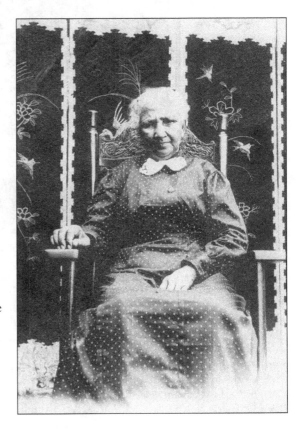

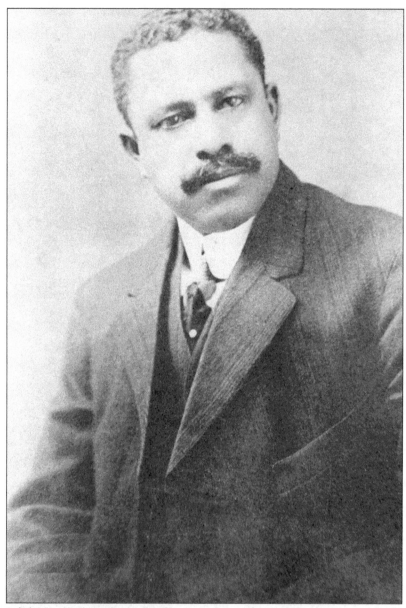

John Merrick (1859–1919) was born into slavery on September 7, 1859, in Clinton, North Carolina. He learned to read, write, and figure without the benefit of a formal education. By age 12, he was working in a brickyard in Chapel Hill to help support his mother. When he was 18, he moved to Raleigh, North Carolina, where he worked as a hod carrier and brick mason and later worked in the William G. Otey barbershop in Raleigh, North Carolina, and married Raleigh native Martha Hunter. As a barber to members of the Duke family, he was persuaded by the Dukes, and his friend John Wright, to journey to Durham to work in Wright's barbershop. By 1880, at the age of 21, Merrick had moved to Durham and become a pioneer business leader and financier. In 1898, the North Carolina Mutual and Provident Association was formed by Merrick and six other African American men and was incorporated on February 28, 1899; on April 1, 1899, operations began. Merrick used his earnings from the barber business to purchase land in present-day Durham's Hayti District. (North Carolina Mutual Life Insurance Company.)

Dr. Aaron McDuffie Moore (1863–1923), pioneer doctor, business leader, churchman, and philanthropist, was born in 1863 to free parents in Columbus County, North Carolina. In 1885, he enrolled in Shaw University in Raleigh. Moore achieved the second-highest score on the North Carolina medical examination out of 40 applicants. In 1888, Dr. Moore came to Durham, where he was the first African American physician to practice. He also served as the first superintendent of Lincoln Hospital from 1901 to 1923. In 1895, he came up with the idea for the Durham Drug Company, and in 1898, he cofounded what would become North Carolina Mutual Life Insurance Company. (North Carolina Mutual Life Insurance Company.)

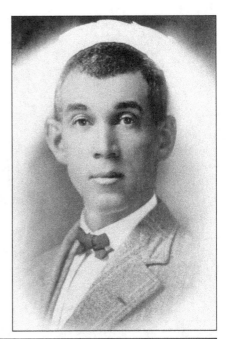

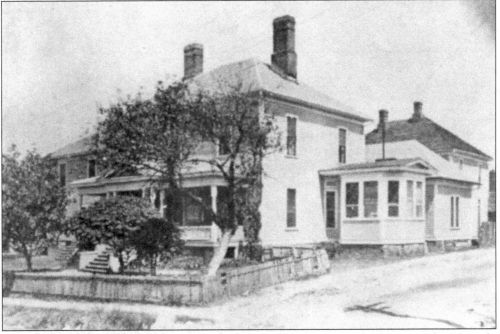

Tobacco magnet Washington Duke was approached by Dr. Aaron M. Moore, John Merrick, and Dr. Stanford L. Warren regarding dire medical conditions in the black community. Duke and his sons James B. and Benjamin N. Duke donated $8,550 for erection of Lincoln Hospital. The two-story wooden structure was dedicated to black citizens on July 4, 1901, at the corner of Proctor Street and Cozart Avenue. The structure was destroyed by fire in 1922. It was the fourth black hospital in North Carolina and first to be non-church affiliated. Dr. Moore helped to train African American doctors and nurses for a life of service until 1976. (North Carolina Mutual Life Insurance Company.)

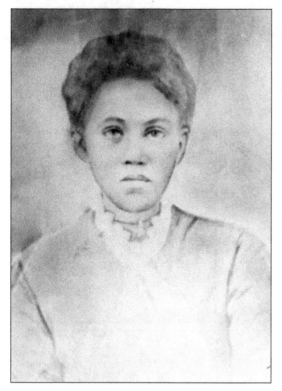

Julia Sellers (1861–1917), seen in this late 1890s image, was born in Orange County, North Carolina, on the eve of the Civil War in 1861. After marrying Jordan Sellers (1862–1916) in 1878, she and Jordan settled in present-day Durham. The family lived at 37 Gregson Street in 1900 and included six daughters: Effie, Minnie, Sadie, Bessie, Lelia, and Coratia. Both Julia and Jordan are interred in Geer Street Cemetery. (Janet Young Peeler.)

Charles Clinton Spaulding Sr. (1874–1952), businessman, community leader, and pioneer, came to Durham in 1896 at the urging of his uncle Dr. Aaron M. Moore for better opportunities. He graduated from the Whitted School in 1898 and later became manager of a local grocery store before entering the insurance industry. His employment with North Carolina Mutual Life Insurance Company began in 1900, and he served as an agent, general inspector, general manager, secretary-treasurer, and as president from 1923 to 1952. He was also president of the Mechanics and Farmers Bank and Mutual Savings and Loan Association until his death. He was a noted interracial leader and served as head of the Durham Committee on Negro Affairs. The Durham community named Spaulding Street and C.C. Spaulding Elementary School in his honor. (North Carolina Mutual Life Insurance Company.)

"Professor" William Gaston "W.G." Pearson (1858–1947) was born enslaved in present-day Durham on the Gary Barbee plantation. (Gary Barbee was the son of George W. and Cynthia Barbee Pearson, who were pioneer landowners in the Hayti community.) Pearson was self-taught until the age of 21 and graduated from Shaw University with the financial support of Gen. Julian S. Carr. Beginning in 1886, he succeeded James A. Whitted as principal of the Whitted School. He served 50 years as "colored" superintendent in the city schools of Durham. Pearson held leadership posts in the Prince Hall Masons and the Royal Knights of King David. He was a cofounder of the North Carolina Mutual and Provident Association and the first cashier of Mechanics and Farmers Bank. (James M. Turner.)

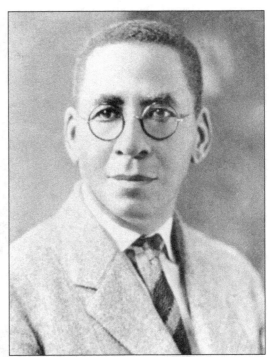

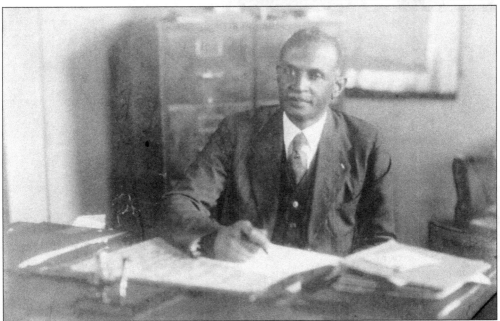

Dr. James E. Shepard (1875–1947) was born in Raleigh and graduated from Shaw University with a pharmacy degree in 1894. From 1899 to 1905, he was a deputy collector for the US Internal Revenue Service in Raleigh. He later accepted a post as field secretary for the International Sunday School Association. In 1909, Shepard chartered the National Religious Training School and Chautauqua for the Colored Race with a mission to train African Americans for a life of learning and Christian leadership. It became the first black, state-supported liberal arts institution in the nation. Shepard served as president from 1910 until his death in 1947. (North Carolina State Archives.)

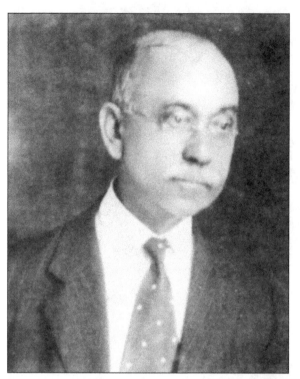

Dr. Stanford Lee Warren (1863–1940) was born in Caswell County during the Civil War in 1863 and came to present day Durham at the age of two with his mother, Annie Warren, a domestic in the home of Washington Duke. Stanford attended the public schools of Durham and Kittrell College. He saved his earnings clerking in the Bull Durham tobacco factory to enter Shaw University's Leonard Medical School and later opened a practice in Durham and served as a physician for over 40 years. He married Julia McCauley in 1904 and was the father of Selena Warren Wheeler. The S.L. Warren Branch Library on Fayetteville Street was named in his honor in 1940. (Selena Warren Wheeler and Warren Wheeler.)

Charles "C.C." Amey (1886–1957) was born in Durham County, the son of Cornelius and Sarah Jones Amey. They were among the first African American settlers and landowners in Durham. A 1903 graduate of the "Negro" North Carolina Agricultural and Technical College, he returned to Durham. In 1911, he became secretary and manager of the Durham Knitting and Textile Mill, an all African American–owned and –staffed mill. He later served as the first business manager at North Carolina College for Negroes during the administration of its founder, Dr. James E. Shepard. Amey was considered one of the first African American lobbyists in the North Carolina General Assembly. (Charles A. Winters.)

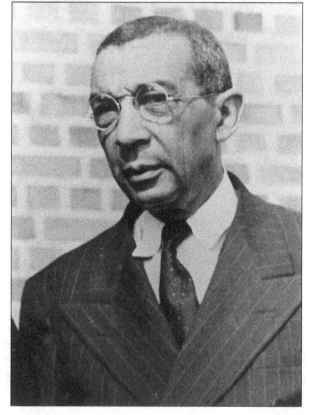

Rev. Edian Markham (1824–1910), founder and first pastor of Bethel AME Church in the Hayti community, came to Durham in 1868, purchased land, and built a log church, which was organized on August 20, 1869, with only six members; it became Durham's second black congregation. The church's name was changed in 1891 to St. Joseph AME Church. Markham married Molly Walden Markham and is buried in the Geer Street Cemetery in Durham. (Andre D. Vann.)

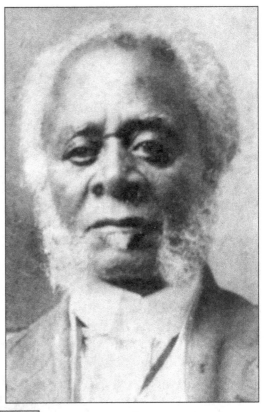

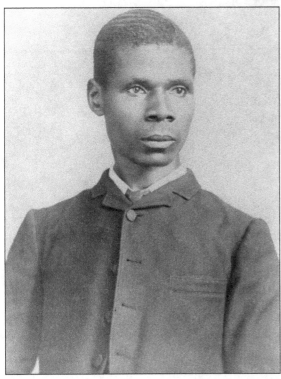

Robert Lee Poole (1859–1913) was born in Granville County, North Carolina, as an enslaved person and received early schooling in a free school in Oxford, North Carolina, taught by "Yankee ladies." He was a second-generation brick mason and worked on projects large and small in Oxford, Henderson, Virginia, and South Carolina. On his first trip to Durham in 1883, to work on a masonry project, he found Durham most hospitable and found much work in building the early tobacco factories and the developing Trinity College (now Duke University). In 1888, he married Beannie Poole Morgan in Hillsborough, North Carolina; the two settled in Durham and built a home and raised a family until Robert's death in 1913. A 1903 registration card noted his membership in the Bricklayers, Masons, and Plasterers Union No. 7 in Durham. (Maggie Poole Bryant.)

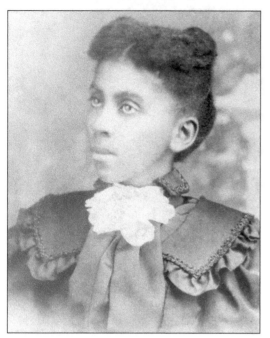

Beannie Ann Faucette Poole Morgan, seen in the early 1900s, was born in 1872 in Hillsborough, North Carolina, to William and Margaret Ruffin Faucette. She later journeyed to Durham and married noted brickmason Robert Lee Poole. Upon the death of Robert in 1913, she married William Morgan. She was the mother of Maggie Lee Poole Bryant (1888–1976), Fezza Ophelia Poole (1891–1908), Fannie L. Poole McLean (1893–1981), Leroy Attucks Poole (1895–1895), Gazella Annie Poole Lipscomb (1896–1998), and Robert Edward Poole (1903–1976). She served as a private duty nurse to many prominent white and African American families and was known to be among the first women to own and drive a car, a four-door Oakland Motor Car. She died in 1931 and is interred in the Beechwood Cemetery in the family plot. (Maggie Poole Bryant.)

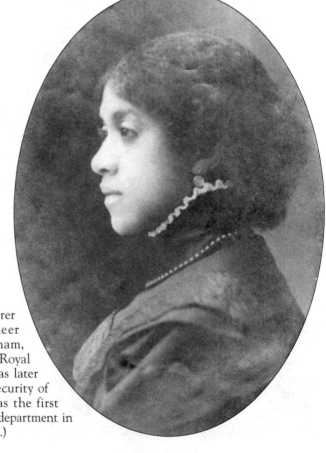

In the early 1900s, Bessie Shearer Gilmer (1883–1966), a pioneer businesswoman, came to Durham, where she was treasurer of the Royal Knights of King David. She was later employed with Employment Security of North Carolina, where she was the first African American hired in the department in the entire state. (Andre D. Vann.)

Two

BLACK WALL STREET AND THE WORLD OF WORK

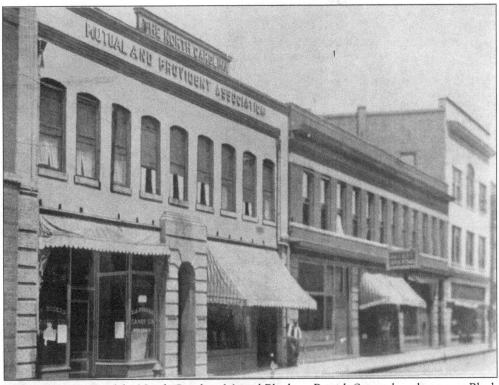

This is a 1906 view of the North Carolina Mutual Block on Parrish Street, long known as Black Wall Street, which has served as a source of pride as African Americans looked inward and upward to uplift the race. Through self-initiative and segregation, they created their own institutions, becoming producers as well as consumers of goods and services. The complex consisted of the North Carolina Mutual and Provident Association, Bull City Drug Store, C.A. Rogers Candy Store, and the offices of Dr. A.M. Moore and Prof. W.G. Pearson (principal of "colored" grade schools in the city). As early as June 1, 1905, members of the North Carolina Mutual board of directors purchased a lot on West Parrish Street for $3,000 and erected a two-story home office at a cost of $6,478.60, which included two one-story stores adjoining the headquarters. The structure was made of brick with a stucco front finish and a pebble roof with modern conveniences. North Carolina Mutual acquired additional lots on Parrish and Church Streets. (North Carolina Mutual Life Insurance Company.)

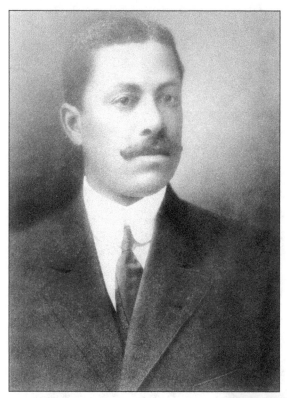

John Merrick, cofounder of the North Carolina Mutual and Provident Association, served as its first president from 1899 until his death in 1919. From small beginnings in the barber business, real estate, and insurance, Merrick became recognized as one of the most outstanding "negro" business leaders of the South. (North Carolina Mutual Life Insurance Company.)

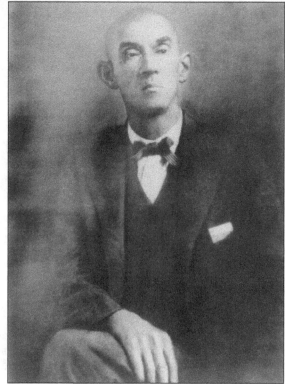

Dr. Aaron M. Moore, a cofounder of the North Carolina Mutual Life Insurance Company, served as its second president from 1919 until his death in 1923. (North Carolina Mutual Life Insurance Company.)

This 1906 image shows the office of C.C. Spaulding, general manager of the North Carolina Mutual and Provident Association. From left to right are Susie Gillie (Norfleet), a stenographer who began service on February 1, 1906, and served a total of 43 years; C.C. Spaulding; and an unidentified employee. (North Carolina Mutual Life Insurance Company.)

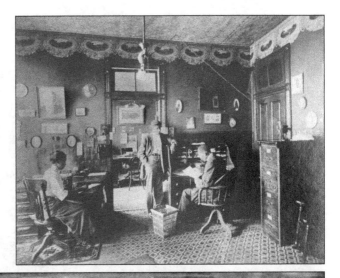

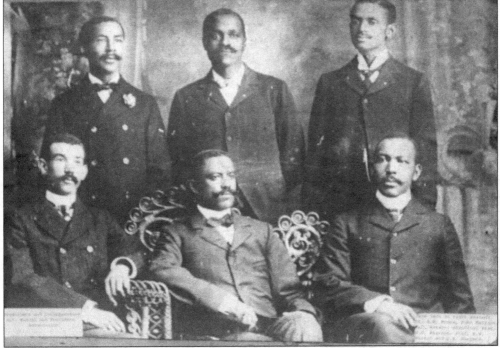

The 1898 incorporators and organizers of the North Carolina Mutual and Provident Association are, from left to right, (seated) Dr. Aaron M. Moore (physician), John Merrick (barber), and T.D. Watson (tin roofing contractor); (standing) Prof. William G. Pearson (educator), Pinkney W. Dawkins (educator), and Dr. James E. Shepard (pharmacist). Other organizers not shown included Edwin A. Johnson (attorney and dean of the law school at Shaw University), Thomas O. Fuller (member of the North Carolina House of Representatives of the General Assembly), and N.C. Bruce (professor at Shaw University). The first officers of the new company were Merrick (president), Dr. Moore (treasurer and medical director), and Watson (secretary and general manager). The association opened for business on April 1, 1899, in a corner of the medical office of Dr. Moore on the second floor of a building at the southeast corner of Main and Church Streets in Durham called "Kempers Corner." (North Carolina Mutual Life Insurance Company).

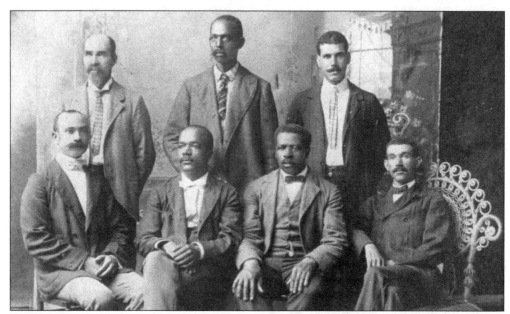

On February 25, 1907, nine African American businessmen and educators received a charter to establish the Mechanics and Farmers Bank. The incorporators pooled their resources for a total of $10,000 capital to ensure that African Americans could get loans, purchase homes, and educate their families. The bank opened for business in August 1908 at 112 W. Parrish Street. Shown are seven of the nine founders: from left to right are (seated) Dr. Stanford L. Warren (physician), Dr. Jesse A. Dodson (pharmacist), George W. Stephens (local grocer), and Dr. A.M. Moore (physician); (standing) Richard B. Fitzgerald (local brick manufacturer), and two unidentified. Other founders included Dr. James E. Shepard (pharmacist and federal appointee), John Merrick (businessman), William G. Pearson (school principal), and Dr. John R. Hawkins (AME Church official). (North Carolina State Archives.)

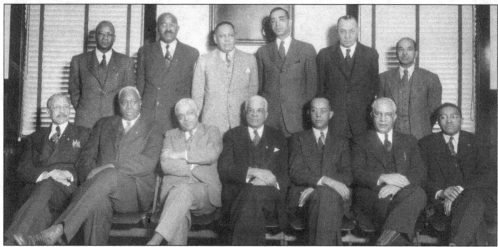

This 1944 image shows the board of directors of the North Carolina Mutual Life Insurance Company. From left to right are (seated) John L. Wheeler, Arthur J. Clement Sr., George W. Cox, C.C. Spaulding Sr. (president), Edward R. Merrick, Martin A. Goins, and William D. Hill; (standing) W.J. Kennedy Jr., Arthur E. Spears Sr., Dr. Clyde Donnell, David C. Deans, Richard L. McDougald, and Asa T. Spaulding Sr. (North Carolina Mutual Life Insurance Company.)

This 1947 image shows Viola G. Turner sitting and smiling as Susie V. Gille Norfleet (1877–1954), a career employee of the North Carolina Mutual Life Insurance Company, is honored upon her retirement after 43 years with the company by White Rock Baptist Church and North Carolina Mutual. She had the distinction of being the first stenographer employed by North Carolina Mutual, and upon retirement, she became the first home office employee of the company to be retired under its pension system. Turner was the first female to be named a company vice president and member of the board of directors, and retired in 1965. (North Carolina Mutual Life Insurance Company.)

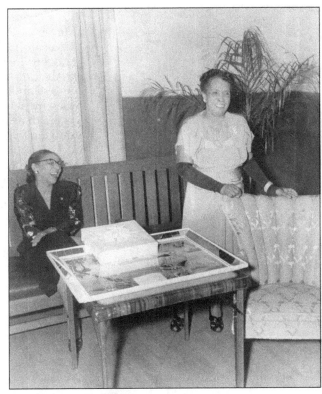

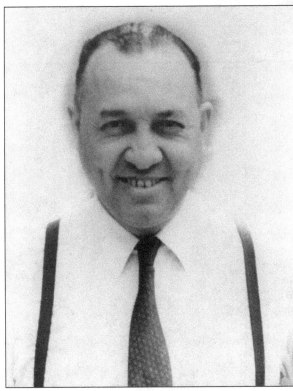

Richard Lewis McDougald (1896–1944), banker, civic leader, and business executive, was a veteran of World War I. He was an early graduate of the National Religious Training School and began his career in banking and insurance in 1919 as a bookkeeper and later served as executive vice president of the Mechanics and Farmers Bank from 1927 to 1944, as well as vice president and founder of the Mutual Building and Loan Association from 1921 to 1944, which was largely responsible for Durham enjoying the highest rate of home ownership among African Americans in the entire United States. The McDougald Terrace public housing complex and the McDougald-McLendon Arena in Durham are both named in his honor. (North Carolina Mutual Life Insurance Company.)

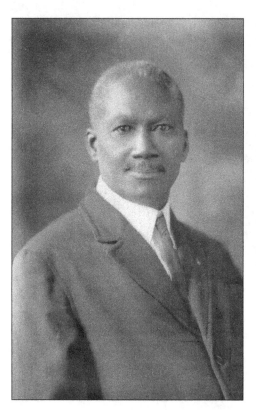

Capt. Peyton H. Smith (1858–1928) served during the Spanish American War in Company H, 3rd Infantry Regiment, North Carolina Infantry. In Durham, he worked in the early tobacco factories and saved his wages until becoming a grocer and later a substantial landowner. Smith was president of Smith Realty and owned much land, including the site of the present-day Durham Farmers' Market on Foster and Roney Streets. He also served as a volunteer in the Black Hook and Ladder Co. in Durham. Smith married Maggie J. Pine, and was the father of Bessie, William L., and Lyda M Smith. He is buried in the Violet Park Cemetery on the site of the present-day St. Titus Episcopal Church. (Andre Carl and Vera Whistenton.)

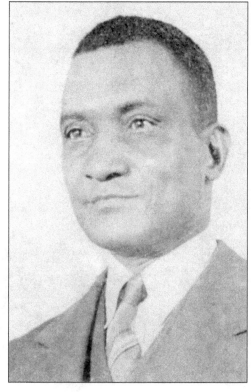

Johnson Herbert Ray (1890–1959), a noted mortician and civic leader, was born in Durham County. He attended the local public schools and North Carolina A&T College in Greensboro, and was a veteran of World War I. In 1918, he married Mary E. White and settled in Durham. He graduated in 1919 from Brown's Embalming School in Raleigh, North Carolina. In 1919, he opened Ray and Sons Funeral Home at 1108 Fayetteville Street along with his sons Johnson Jr., Harold, and Douglas C. Ray. He is interred in Beechwood Cemetery. (Andre D. Vann.)

Theodore Speight (1908–2008), a pioneer businessman, churchman, and mentor to countless aspiring business owners, illustrated the importance of operating a family-owned business by employing his immediate and extended family at Speight's Auto Service Center on Fayetteville Road. As an entrepreneur, he established the Biltmore Service Station, a deluxe cab fleet, and Pure Oil Service in the Hayti community and later at the corner of Barbee Road and Fayetteville Street with the slogan "A Business with a Soul." He served as president and chairman of the board of the Durham Business and Professional Chain for over 30 years. As a churchman, he was a member of Mt. Vernon Baptist Church for over 30 years, and later, along with his brother Charlie Speight, donated land for Community Baptist Church, where he had dual membership and served as a deacon for more than 50 years. Speight's Auto Service is in its second generation, with his daughter Theodora S. Manley and Melvin D. Speight continuing the family business. (Theodora Speight Manley.)

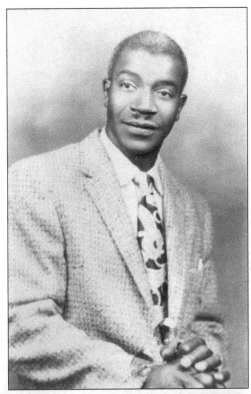

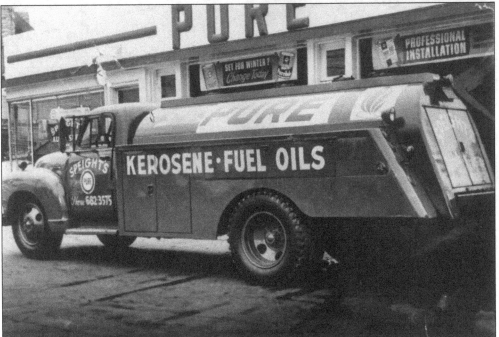

This truck used by Speight's Auto Service offered delivery of fuel oil and kerosene to customers beginning in 1959. This photograph was taken in front of the business, located at the corner of Fayetteville and Pettigrew Streets. (Theodora Speight Manley).

This 1950s image shows Ellis D. Jones Sr. and Jr., morticians and owners of the Ellis D. Jones and Sons Funeral Home, established in 1935. Before establishing the mortuary business, Ellis Sr. was an insurance agent with the North Carolina Mutual Life Insurance Company, a real estate businessman, and an early officer of the Royal Knights of King David. The firm, located at 419 Dowd Street, also housed the Fireside Mutual Burial Association, sold floral arrangements, and offered notary service and an ambulance service. In 1947, Ellis Jr. joined his father in the firm, and it is now in its fourth generation of family ownership. (Ellis D. Jones and Sons Funeral Home.)

This 1938 image captures the first graduating class of Madam Jacqueline DeShazor Jackson's Beauty College and System in St. Joseph AME Church. The business began in 1936 after the DeShazor sisters moved to Durham and began operation in 1936 at 809 Fayetteville Street. From left to right are (seated) Jackson and her sisters Vera M. DeShazor and Eva Bishop Mock. This class was the first to complete the course in beauty culture offered by the college. The college graduated over 6,000 cosmetologists during its 42 years of existence. (*Carolina Times*.)

Henry McKinley Michaux (1897–1986), a native of Burke County, North Carolina, journeyed to Durham to attend the National Training School, where he graduated in the class of 1921. He organized Union Insurance and Realty Company in 1924, which in 1928 merged with the Merrick-McDougald-Wilson Company. The company offered construction, real estate, general insurance, repairs, and building supplies. For 65 years, Michaux served as a civic and business leader in the Durham community. He was chairman of the board of four family enterprises: Union Insurance and Realty Company, Glenview Memorial Park in Raleigh, Washington Terrace Apartments and Shopping Center, and Terrace Insurance and Realty Company. He served as a member of the James E. Shepard Memorial Foundation and was a founding director of the North Carolina Central University Foundation. He was joined in business with his two sons, Rep. H.M. "Mickey" and attorney Eric Michaux, the second generation of the businesses. (H.M. and Eric Michaux.)

The Michaux Building, located on Highway 55, is owned and operated by Union Insurance and Realty Company and was built in 1972. The two-story structure has over 10,000 square feet and is owned by H.M. and Eric Michaux. (H.M. and Eric Michaux.)

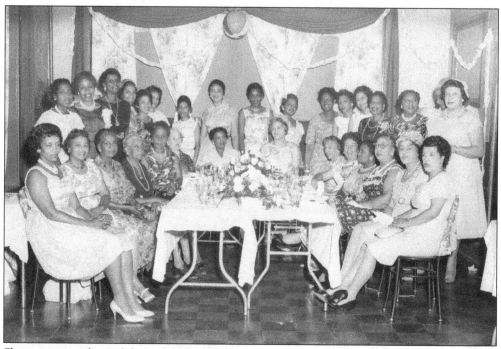

Shown are members of the Iota Phi Lambda business sorority at a dinner in honor of member Viola G. Turner. (Maggie P. Bryant.)

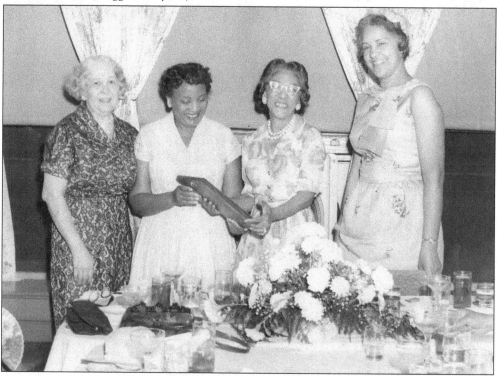

From left to right, members of Iota Phi Lambda Eula Wade Perry Harris, Helen Jones, Viola Turner, and Louise C. McCrea are shown at the recognition dinner for Turner. (Maggie P. Bryant.)

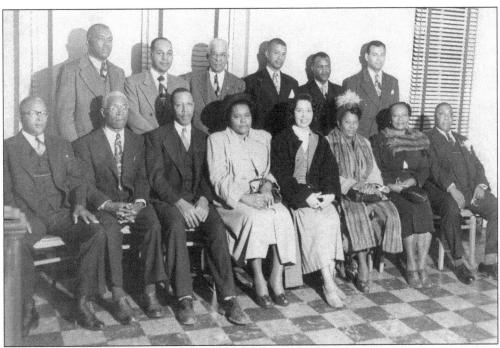

Pictured on January 10, 1950, is a group of shareholders and visitors to the 28th annual meeting of the Mutual Building and Loan Association. They were in attendance for the first time at the meeting of the association and asked to pose with Pres. C.C. Spaulding and secretary-treasurer John S. Stewart. From left to right are (seated) Rev. G.W. Troublefield, Fred Edwards, Pinkney Gerald, Jessie Atwater, Mrs. Charles Stewart, Maude Thorpe, Bessie Dunston, and John H. Williams; (standing) Fred Cuttino, J.S. Stewart, C.C. Spaulding, John Coone, Noah McCliamb, and John L. Stewart. (North Carolina Mutual Life Insurance Company.)

Four presidents of the North Carolina Mutual Life Insurance Company are pictured here. Standing from left to right are fifth president Asa T. Spaulding Sr. (1959–1967), seventh president William J. Kennedy III (1972–1990), and sixth president Joseph W. Goodloe (1968–1972). Seated is fourth president William J. Kennedy II (1952–1958), a member of the second generation of leaders of the company. (North Carolina Mutual Life Insurance Company.)

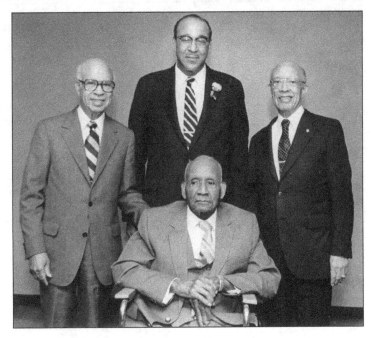

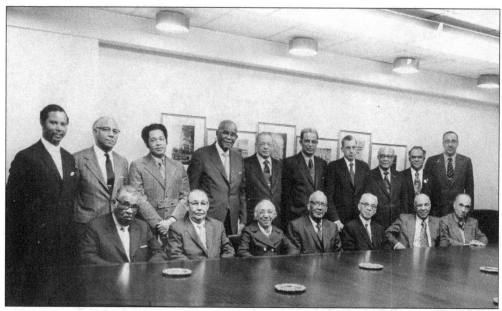

The 1972 members of the board of directors of Mechanics and Farmers Bank included, from left to right, (seated) Charles C. Spaulding Jr., William J. Walker, Viola G. Turner (the first woman on the board of directors), W.J. Kennedy Jr., J.E. Strickland, John S. Stewart, and Charles "Doll" Haywood; (standing) John C. "Skeepie" Scarborough III, Dr. Albert N. Whiting, Nathan Garrett, Arthur E. Spears Sr., John H. Wheeler (president of the bank), Malachi L. Greene, Joseph Sansom, Joseph W. Goodloe, John W. Winters, and W. J. Kennedy III. (Mechanics and Farmers Bank).

Maceo Kennedy Sloan Jr., a fourth-generation business executive with ties to the founders of North Carolina Mutual Life Insurance and Mechanics and Farmers Bank, is a native of Durham. He founded NCM Capital Management and served as chairman, president, and CEO of NCM Capital Management Group and NCM Capital Advisers. Later, he formed Sloan Financial Group, a financial holding company that is consistently listed as one of the top 75 most powerful blacks on Wall Street in *Black Enterprise* magazine. He served as chairman of the board of trustees for TIAA–CREF. In 2016, NCM Capital Management was acquired by another African American firm, Piedmont Investment Advisors, also based in Durham. (North Carolina Mutual Life Insurance Company.)

Vivian Rogers Patterson, a banker and community leader, began service with the Mechanics and Farmers Bank in 1944 as a teller. She rose quickly through the ranks and served as assistance vice president from 1967 to 1968 and was promoted to vice president in 1968; she was named corporate secretary from 1979 to 1990 and served as trust officer beginning in 1980. She retired from the bank in 1992 as vice president, trust officer, and a pioneer African American woman banker in Durham. She is a member of Delta Sigma Theta sorority and St. Titus Episcopal Church. (Vivian Rogers Patterson.)

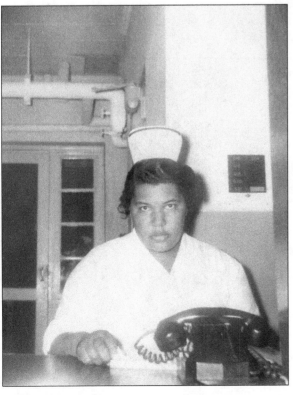

Nurse Marion Juanita Glenn Miles was born in Durham County and graduated from Little River High School in 1950. She graduated from Lincoln School of Nursing in 1954 and accepted a position as evening staff nurse at Lincoln Hospital, remaining with the hospital in various capacities. When Lincoln merged with Watts Hospital, Miles held the position of recovery room staff nurse at Durham County Regional Hospital until she retired in 1980. She later worked for the IBM corporation and retired as senior associate nurse in 1993. Miles volunteers with the Community Health Coalition and often coordinates and distributes health education information in the community. She received the President's Volunteer Service Award for work in the health community. (Marion Glenn Miles.)

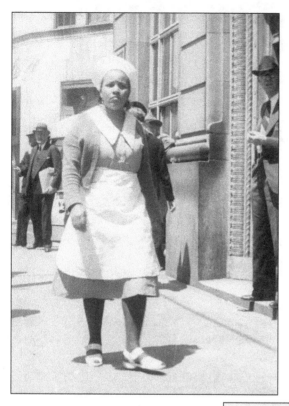

Janie Mae Fletcher (1907–1995), a tobacco worker with the Liggett & Myers Tobacco Company, is shown in her typical work uniform as she walks down the street while leaving the tobacco factory on Morgan Street. African American women witnessed differences and segregation in the tobacco factories throughout Durham. (Dr. William T. Fletcher.)

R. Kelly Bryant Jr. (1917–2015), a business executive, scouting leader, and community historian, was a native of Rocky Mount, North Carolina, and a descendant of Margaret Faucette, early community builder in Hayti. He came to Durham in 1941 and began working for the Mutual Savings and Loan Association as an accountant until 1944, when he began working for the North Carolina Mutual Life Insurance Company. Bryant retired in 1981 as assistant secretary of the Conservation Department after 37 years of distinguished service. He was known as a community historian and expert on the history of Black Wall Street in Durham, and chronicled the history of Durham's notable African American business community. He was an early civil rights activist and was instrumental in desegregating scouting in Durham and all of North Carolina. (Maggie P. Bryant).

Three

CHURCHES AND
RELIGIOUS LEADERS

The first masonry White Rock Baptist Church building was located at 601 Fayetteville Street at the corner of Mobile Avenue and was constructed from 1893 to 1896 under the leadership of Rev. Allen P. Eaton, who served as pastor from 1886 to 1897. The Gothic Revival structure had an initial seating capacity of 350 and was renovated in 1911 under the leadership of Rev. Dr. Augustus Shepard, pastor from 1901 to 1911. The renovated structure extended the seating capacity to 800, including the balcony. It also included a new front, library, public baths for a fee, and an elevated floor in the main sanctuary, plus a pipe organ, all at a cost of $26,000. The structure was demolished as a result of an urban renewal project that razed many properties in 1967. The first formal wedding in the structure was between Margaret Kennedy and Lewis M. Goodwin in 1941. (Andre D. Vann.)

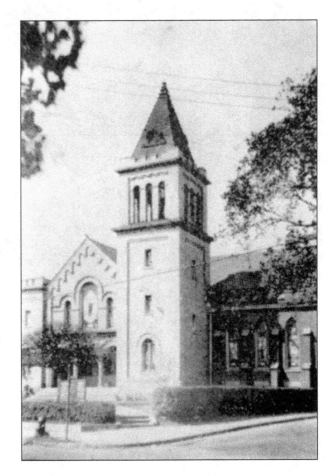

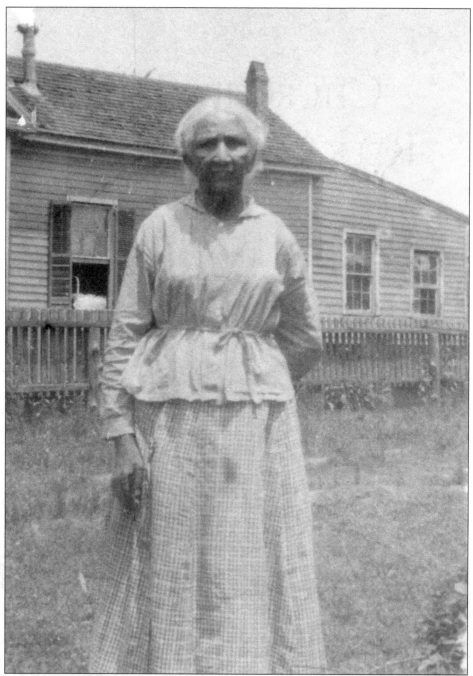

Margaret "Maggie" Faucette, cofounder of White Rock Baptist Church, was regarded as a woman of high Christian principals who worked tirelessly in the Hayti neighborhood and was known to take soup to the sick. She later lived with her daughter Nannie G. Cooper, a public school teacher in the West End area of Durham, at 409 Pine Street (present-day Roxboro Street). Faucette died on October 21, 1920, at the age of 98; two of her children lived to almost 100 years old, as did several grandchildren and great grandchildren. She is interred in the historic Geer Street Cemetery in Durham. (Maggie Poole Bryant.)

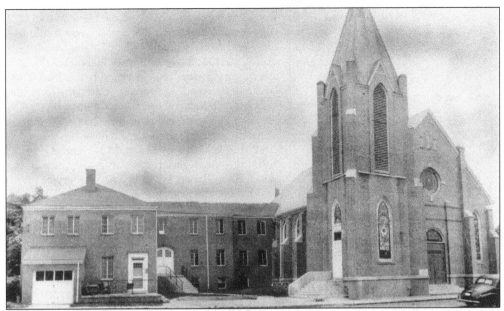

St. Joseph AME Church, located at 809 Fayetteville Street, was formed in 1869 as the second black congregation in the African American community. The Victorian church was designed by S.T. Leary, who designed many buildings for Washington Duke, a financial supporter of the church and whose likeness is featured in a stained-glass window in the northeast corner of the sanctuary balcony area. The bricks came from Richard B. Fitzgerald's brick yard, and electricity was added by Edward N. Toole, the first African American registered electrician in North Carolina. The last church service was held on February 15, 1976, after which members walked down Fayetteville Street to the new sanctuary. The structure survived urban renewal and is listed in the National Register of Historic Places. (Andre D. Vann.)

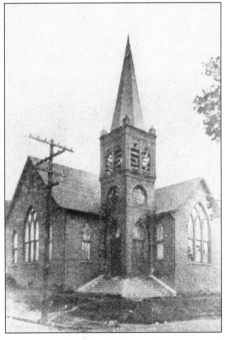

This is a 1920s image of the stately Gothic Revival brick Pine Street Presbyterian Church, located at the northeast corner of Poplar and Pine Streets. It was built in 1893 and was the first church building erected by the small African American Presbyterian congregation in the Durham community, whose roots date back to 1887. The congregation changed its name to the Twine Presbyterian Church and is presently called Covenant Presbyterian Church. The building was demolished in 1978 as a result of urban renewal. (Durham Historic Photographic Archives.)

Mt. Zion Baptist Church, pictured here in the 1940s, was located on Fayetteville Street in the Pearsontown section of Durham. It was founded in 1909 as Good Hope Baptist Church. As the congregation grew, the old structure was torn down and a newer, modern church was constructed with a full-sized basement and classroom for a total of $12,000. During construction, the pastor and the congregation met in the home of Haywood and Maggie Holloway Dixon. In November 1936, the congregation voted to change its name to Mt. Zion Baptist Church. The first service was held in the new church in December 1936, with Dr. James E. Shepard, president of North Carolina College for Negroes, as guest speaker during the 11:00 a.m. service. (*Carolina Times.*)

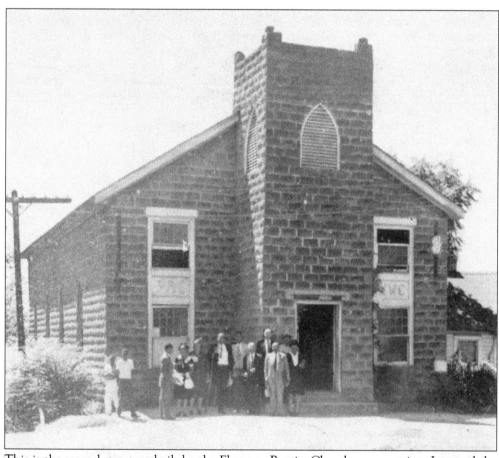

This is the second structure built by the Ebenezer Baptist Church congregation. It served the congregation from 1926 until 1951. (Ebenezer Baptist Church.)

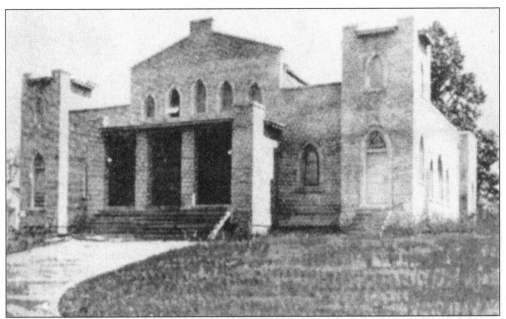

This 1922 photograph shows the Gothic Revival gray brick structure that was the second church building used by the St. Mark AME Zion Church from 1922 to 1953. The structure included the sanctuary, which seated 300 and an additional 150 in the Baraca Room, plus 30 in the balcony. The congregation dates to 1890, when Rev. C.H. McIver and church members Gaston Bynum, William and Flora Colley, Derbie and Jerry Richmond, Jordan Wilson, and Sarah Marsh formed the church in the home of the Colley family on Willard Street. The church was located at 529 Pine Street (present-day Roxboro Street) and was demolished in 1954. (Durham County Photographic Archives.)

Rev. Dr. Hermors "H.H." Hart (1895–1953) was called as pastor of Second Baptist Church, now known as First Calvary Baptist Church, on the West End from 1933 to 1937 and returned in 1947. Under his leadership, a new church was erected at a cost of $100,000. He was a civic and educational leader and was grand chaplain of the Prince Hall Affiliated Masonic Lodge of North Carolina and a member of the executive board of the Lott Carey Baptist Foreign Mission Convention, USA. Hart was presented with an honorary degree from his alma mater Shaw University in 1950. (Andre D. Vann.)

Rev. Thomas Alvis "T.A." Grady (1892–1950), a Hillsborough, North Carolina, native, entered the ministry at the age of 17 and received formal education at the National Religious Training School and Chautauqua, now North Carolina Central University. He began serving as pastor at Good Hope Baptist Church (later Mt. Zion Baptist Church). Grady later led the West Durham Baptist Church congregation and spent his last 26 years in the ministry at the Ebenezer Baptist Church. Under his leadership at Ebenezer, the congregation tripled, and at his death, a new $60,000 structure was under construction. The T.A. Grady Recreation Center is named in his honor. (Martha Grady Dalton.)

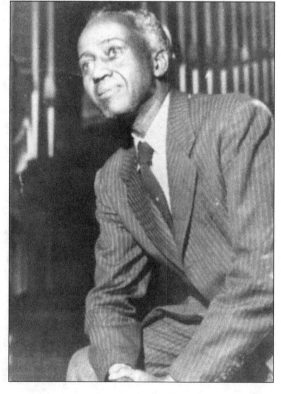

Rev. Dr. Miles Mark Fisher (1899–1970), a minister, educator, author, and community leader, served as pastor of White Rock Baptist Church from 1933 to 1965. In 1953, Fisher wrote *Negro Slave Songs* to critical acclaim and won the American Historical Association's prize for outstanding historical volume for 1953. In 1954, Fisher was listed by *Ebony* magazine as one of the nation's 10 outstanding preachers. He was instrumental in opening the church to the community by offering recreational programs and activities for African American youth and was recognized by the National Recreation Association; Fisher was also a recipient of the association's Golden Anniversary Award in 1958. (Florida Fisher Parker.)

Judge Mayme Dowd Walker (1880–1960) was the first woman appointed judge of the juvenile court in Durham City and Durham County, and played a tremendous role in the African American community in Durham. She was also the first woman judge in North Carolina when she was appointed in 1934, and except for one term (1941–1942), was reappointed until retirement in 1949. She created councils to prevent delinquency and established black and white safety patrols with the cooperation of African American leaders. She championed rehabilitation over incarceration for those under age 18. She was a cofounder of the John Avery Boys Club. She was also appreciative of the work of Dr. Miles Mark Fisher, who opened the White Rock Church properties to give black youth wholesome opportunities for recreation and entertainment. (Milo Pyne.)

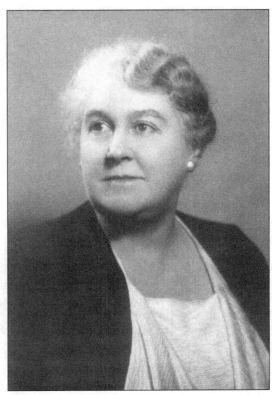

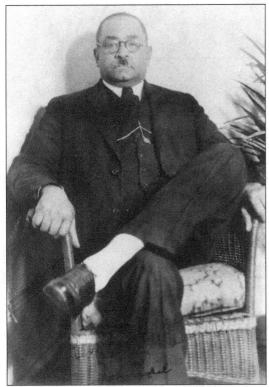

Rev. Dr. Charles Edward McLester (1889–1966) came to Durham in 1937 to serve as pastor of Second Baptist Church, now known as First Calvary Baptist Church. He was known as the "Gospel Tornado" and was an eminent scholar and pastor. As a result of disharmony, McLester and several church members left, and he became the founder and organizer of the Morehead Avenue Baptist Church, organized on July 17, 1946; the church building was dedicated in 1951. (Andre D. Vann.)

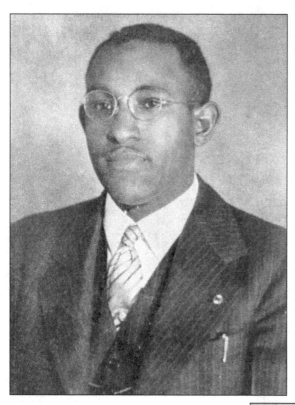

Rev. Simon Peter "S.P." Cooke (1905–1991) a native of Henderson, North Carolina, attended high school at Henderson Institute, then Kittrell College and Virginia Union University. He served as pastor of Kyles Temple AME Zion Church from 1948 to 1953. Cooke was a minister in the church for 50 years and a barber for 65 years. (Rebecca Cooke Hunt.)

Rev. Dr. Lowry Wilson "L.W." Reid (1913–1995), the pastor of New Bethel Baptist Church in the Crest Street community from 1945 until his retirement, found a community in disrepair, with no paved streets, hardly any street lights, and a one-room schoolhouse. Over the course of his 44-year tenure, he was instrumental in the redevelopment of the entire Crest Street community, which stood directly in the path of the planned east-west expressway (North Carolina Route 147). Reid successfully brought suit to save the community from urban renewal, which became a national model for relations between communities and the federal government. During his tenure as pastor, he improved the church's physical plant and founded a daycare center and play school and led the planning for the establishment of the new Crest Street Elementary School. In 1992, the L.W. Reid Home for the Elderly was named in his honor. (New Bethel Baptist Church.)

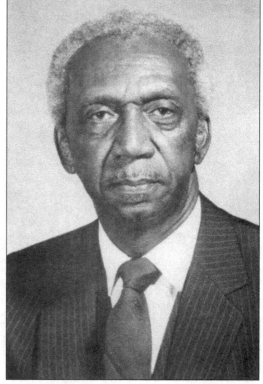

Edgar Daniel Barnes (1877–1967), a noted layman and church building contractor, came to Durham in 1924 and became a member of St. Mark AME Zion Church and its trustee board. He quickly recognized the need to expand the AME Zion Church, and in consultation with Bishop Kyles, organized Kyles Temple AME Zion Church on Dunston Street. Barnes served as chairman of the trustee board for a number of years and is buried in Beechwood Cemetery in the Barnes family plot. (*Carolina Times.*)

Rev. Dr. Lorenzo A. Lynch, a fourth-generation minister, served as the 14th pastor of the White Rock Baptist Church from 1965 to 1993. He and his wife, Lorine Harris, are the parents of Rev. Leonzo D. Lynch, former US Attorney General Loretta Lynch, and the late Lorenzo Lynch Jr.

39

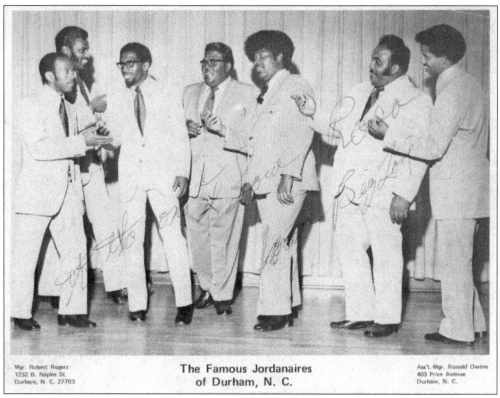

The Famous Jordanaires gospel group, shown in this 1970s image, has performed throughout Durham and the surrounding areas since 1957. (Dr. William T. Fletcher.)

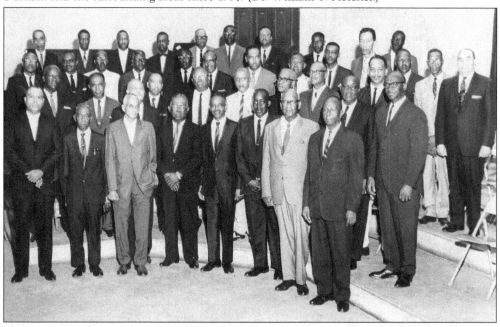

Shown are members of the Moore-Kennedy Bible class of White Rock Baptist Church. (Janet Young Peeler.)

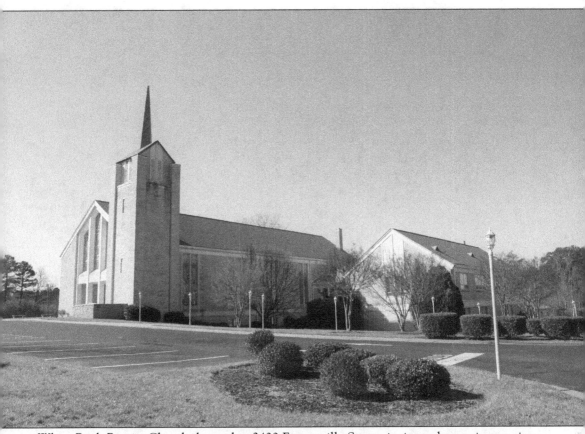

White Rock Baptist Church, located at 3400 Fayetteville Street, is situated on a six-acre site purchased by the Vickers family as a new place of worship following urban renewal in the Hayti district. While the structure was under construction, worship services were held at St. Joseph AME Church and in the B.N. Duke Auditorium on the North Carolina Central University (NCCU) campus. The cornerstone for the $1 million church was laid on April 23, 1977, and it was officially dedicated on October 23, 1977. The sanctuary experienced a modern $800,000 renovation that included new furniture, a historic 32-rank Moeller pipe organ, and new stained-glass windows. In 1998, a Child Development Center was opened to serve the needs of the community. The congregation celebrated its 150th anniversary in October 2016. The church is under the leadership of Rev. Dr. Reginald Van Stephens, who began his ministry in 1995. (Dr. Jerry Head.)

Bishop Philip R. Cousin Sr. was ordained in the AME Church in 1952 and served as pastor of several churches in Florida, Virginia, and North Carolina. He later served as president of Kittrell College from 1960 to 1965 and was appointed pastor of St. Joseph AME Church in September 1965. He preached his first sermon on September 26, 1965, on the subject "Back to Bethel," and during his tenure at St. Joseph, he led the building of a new $65,000 parsonage and a new church plant valued at $1.3 million. St. Joseph served as the center of the civil rights movement and was a gathering place for sit-in demonstrators and activists. Cousin was the first black faculty member of the divinity school at Duke University (1967–1979). He was elected to the episcopacy of the AME Church at the general conference in 1976 and was named the 96th bishop of the AME Church. (*Carolina Times*.)

Rev. John Henry Peppers (1899–1965), a native of Wake County and graduate of Shaw University, came to Durham in 1936 to serve as pastor of St. Paul Church, which is known now as the Greater St. Paul Baptist Church. He was a member of the East End Betterment League and Doric Lodge. Peppers is interred in Beechwood Cemetery. (Andre D. Vann.)

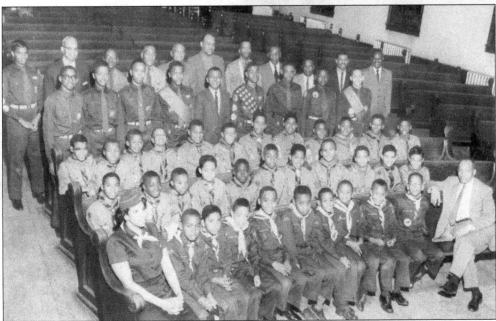

Cub Scout Pack 55 leaders and scouts are pictured in the sanctuary of White Rock Baptist Church following Scout Sunday service in 1960. Pack 55 was formed in 1944 by scout leader James M. Schooler Sr., pictured in the first row at far right. Schooler served as cub master from 1944 to 1961. His sons James M. Jr., William R., and Kyle E. Schooler were the first scouts in the pack. (Andre D. Vann.)

Rev. Dr. Coolidge McCoy (1929–2014) and his son Bishop Samuel George McCoy Sr. (1906–1999) represent two generations in the ministry. Reverend McCoy served as a police officer with the Durham Police Department and as a minister in Durham and Franklin Counties. Bishop McCoy, a native of Bladen County, served as pastor of Mt. Olive United Holiness Church, district elder for the Northwestern District of the United Holy Church for 12 years, and secretary of the United Christian College for the Northwestern District. He also served as vice president of the Southern District United Holy Church Convocation, and was named vice president emeritus in 1997. (Vivian McCoy.)

Georgia Bullock Thompson (1904–1995) a native of Robeson County, received her education in the Lumberton public schools and attended the Thompson Institute. She came to Durham in 1932 and joined the Mt. Vernon Baptist Church. In 1950, she began work with North Carolina College at Durham and retired as supervisor of the campus guesthouse. She was a member of the Woman's Baptist Home & Foreign Missionary Convention of North Carolina executive board, president of the New Hope Missionary Baptist Association Auxiliary, and a member of both the Lott Carey Foreign Missionary Convention of America and the Progressive National Baptist Congress. (Velton P. Thompson.)

Four

THE FAMILY ALBUM AND COMMUNITY SNAPSHOTS

The four living children of Robert Lee and Beannie Faucette Poole Morgan are seen here in a formal setting in the 1950s. From left to right are Robert Edward Poole (1903–1976), Annie Gazella Poole Lipscomb (1896–1998), Maggie Lee Poole Bryant, and Fannie Poole McLean (1893–1981), all born and raised in the Hayti community of Durham. (Maggie Poole Bryant.)

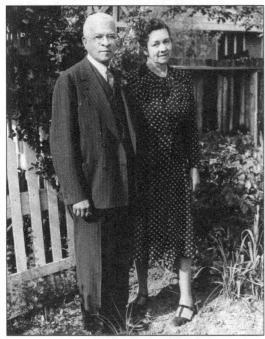

North Carolina Mutual Life president Charles Clinton "C.C." (1874–1952) and Charlotte Garner Stephens Spaulding (1878–1971), who were married in 1920, are shown in the 1940s in the yard of their home on Fayetteville Street. (North Carolina Mutual Life Insurance Company.)

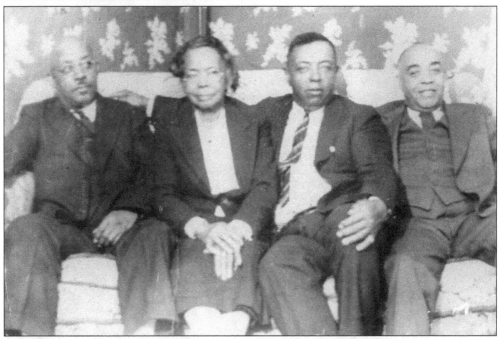

Members of the Holloway-Robbins family are pictured in the early 1950s. From left to right are son George Pearson Holloway (1890–1955); mother Anna Viola Curtis Holloway Robbins (1870–1951), widow of John Holloway and later Elder George Robbins; son Joseph Simeon "Sim" Holloway (1889–1960); and son John Lucius Holloway Sr. (1892–1966). All were born in Durham County and were members of the Mt. Gilead Baptist Church. They are buried in the Holloway plot in Beechwood Cemetery. The only daughter of Anna was Roxie Holloway Rowland (1896–1997), who is not pictured. (Claudette Free.)

This 1940s photograph shows Nannie Cooper
Greene (1918–1998) and her mother, Nannie Gazella
Faucette Cooper (1876–1952), in the front yard of
Nannie's home at 508 Massey Avenue. Nannie
Gazella Faucette Cooper was a native of Orange
County and was the daughter of William and
Margaret Ruffin Faucette, and formerly lived at 409
Pine Street. She was a longtime teacher at the East
End School of Durham. (Maggie Poole Bryant.)

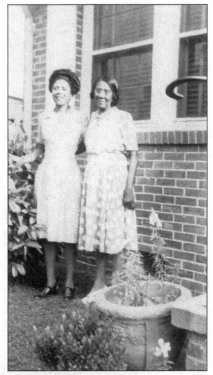

Members of the extended Spaulding and
Bridgeforth families assembled on the lawn for a
dinner party at the home of hosts Asa T. and Elna
Spaulding, D. Fuller and Reba Spaulding, and
A.E. and Lula Spaulding Jackson in 1959. (North
Carolina Mutual Life Insurance Company.)

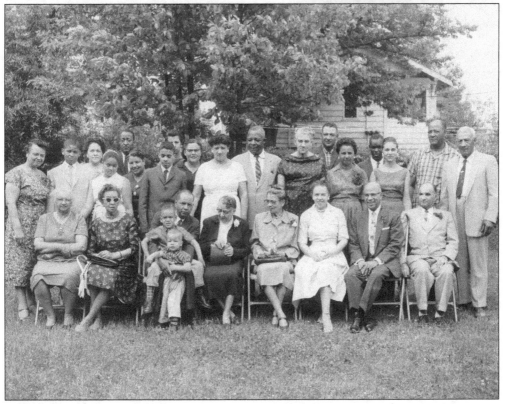

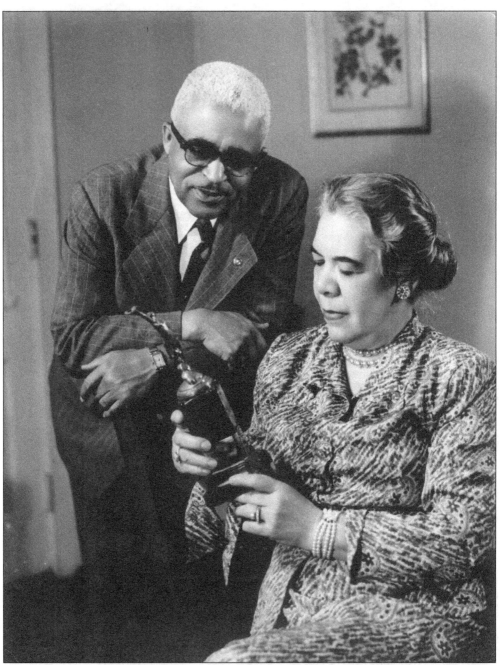

George Wayne Cox Sr. (1890–1956) and Nola Stuart Cox (1896–1973) admire a trophy in the 1950s. The couple were married in 1914 in Rodney, Mississippi, and arrived in Durham in 1923 as Cox joined the North Carolina Mutual Life Insurance home office staff. In 1932, he was promoted to vice president/agency director. He also served as vice president of the Mutual Savings and Loan Association and the Mechanics and Farmers Bank. The couple became fixtures in the Durham community and were active members of the St. Joseph AME Church. They were the parents of Nola Mae, Irma, and George W. Cox Jr. (*Carolina Times*.)

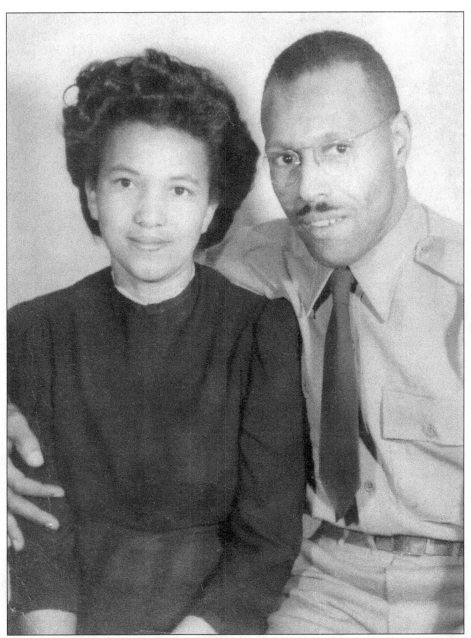

Althea McAden and Irwin R. "Bus" Holmes Sr. (1910–1984) are pictured during World War II. They met at and graduated from North Carolina College for Negroes and later married in 1937. Bus was drafted into the US Army, served with distinction, and was discharged in 1946 with the rank of first lieutenant. In 1947, the couple returned to Durham, where Althea served as supervisor of arts and crafts in the county school system and Bus became a pioneer African American supervisor of recreation activities for "Negroes" at the W.D. Hill Recreation Center; he later became special assistant to the city manager and supervisor of housing inspectors until his retirement in 1975. The I.R. Holmes Recreation Center at Campus Hills is named in his honor. The couple lived on South Alston Avenue and were members of White Rock Baptist Church. They were the parents of Carol and Irwin R. Holmes Jr. (Irwin R. Holmes Jr.)

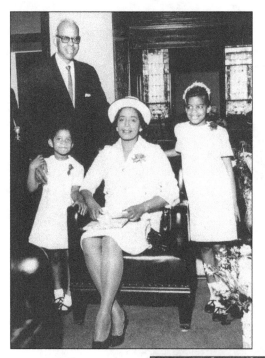

Pictured in 1965 are, from left to right, William A. Clement, Josephine Millicent Clement, Josephine Dobbs Clement (1918–1998), and Kathleen Ophelia Clement. Josephine Dobbs Clement was named Mother of the Year by White Rock Baptist Church. The couple moved to Durham in 1946 when William joined the North Carolina Mutual Life Insurance home office staff. Josephine, a native of Atlanta, Georgia, and a Spelman and Columbia University graduate, taught at present-day North Carolina Central University. She also became active in local civic, religious, and political affairs. In 1973, she was appointed by the Durham City Council to the Durham City Board of Education, where she became the first black woman on the school board. She served on the board for 10 years, with five as chair. She later served as a Durham County commissioner. The Josephine Dobbs Clement Early College High School is named in her honor. (Arthur John Clement.)

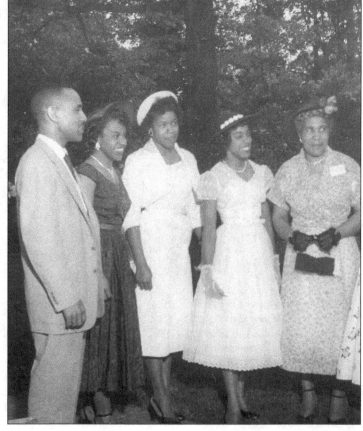

The children of Joseph "Sim" and Zelma Slade Holloway are pictured during a lawn reception. From left to right are Hiliary "Hip" Holloway, Margaret Holloway, Zelma Holloway, Lily Holloway, and Zelma Slade Holloway. (*Carolina Times.*)

Norfleet Whitted, the son of London and Mary Sneed Whitted, was born in Durham on Fayetteville Street. He attended the local public schools and was in the first class to graduate from Hillside High School in 1923. He attended North Carolina College for Negroes from 1924 to 1925 until his father became ill; he then worked to support his family. Whitted began working at WDNC as a janitor in 1934 and, by 1954, was the station's director of black affairs. That year, he resigned from WDNC to serve as program director for the newly formed WSRC radio station, eventually retiring in 1970. (Kris Mayfield.)

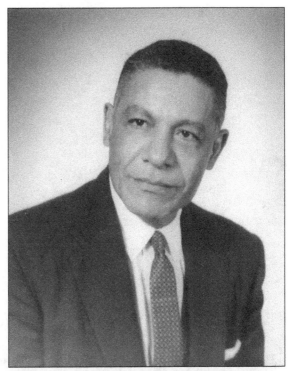

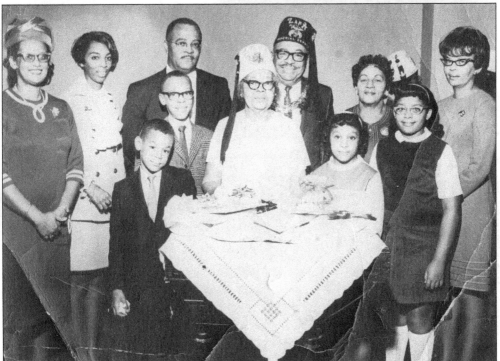

Laura Pookrum Burnette (1888–1978, center) is shown with members of her family as she was honored by Zafa Court No. 41, Daughters of Isis, as "Mother of the Year." She was a charter member and held the office of inside spy. (Catherine B. Mangum.)

This iconic 1970s photograph shows Marion Glenn Miles (seated) with son Carlton Glenn Miles (left) and his father, John Henry Miles. (Marion G. Miles.)

Robert Lawson and his wife of 49 years, Clara, hold their grandchildren as their daughter Apryle Lawson Daye and son-in-law Thomas R. Daye pose for this family photograph. Robert Lawson served as North Carolina Central University's official photographer from 1992 until retirement in 2013 and enjoyed a 50-year association with the institution, having worked with Alex M. Rivera, North Carolina Central's first photojournalist. (Clara Lawson.)

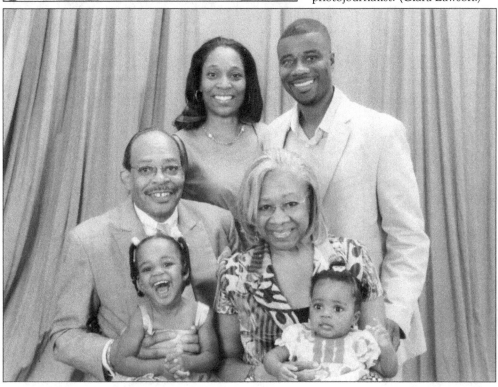

Lee M. Goode Sr. (1927–2006) and his wife, Mildred B. Goode (1925–2005), were married on March 30, 1952, and came to Durham, where they both taught in the Durham Public Schools. Lee served as principal in the Durham Public Schools for 29 years at Lyon Park, Walltown, and Burton Elementary School. Mildred taught for a total of 45 years and retired in 1991. Both volunteered countless hours in the Durham community. (Andre D. Vann.)

Albert Dennis (1922–1994) and Andolia Oakley Eaton (1922–2014) were both recipients of awards for community service in the Durham community. Albert Eaton was a volunteer at the W.D. Hill Recreation Center and received certificates from North Carolina governors James G. Martin and James B. Hunt. Andolia Eaton, a teacher in the Durham city school system for 35 years, taught generations of students and received over 30 awards for volunteer services. She started Kids On My Block, inviting neighborhood children into her home on Dunbar Street for story time and literacy support and awarding each child a book. (Andre D. Vann.)

Robert L. Cotton (1870-1953) is shown with his daughter Mary Etta Cotton Grant (1919–2008) on her graduation day in 1940 from Bennett College in Greensboro, North Carolina. Grant taught for 42 years in the Durham Public Schools, including the Lyon Park School on the West End. (Carolyn A. Grant.)

From left to right are William L. Cook, father of the bride; his daughter, Joyce Cook; her husband, Norman Williams; and her stepmother Owen Plummer Cook after a double-ring ceremony conducted by Rev. Dr. Melvin C. Swann in the Cook home on Jan. 2, 1960. (Andre D. Vann and Alex M. Rivera Jr.)

In 1979, Bessie E. McLaurin (1895–1995), a noted educator and civil rights leader, was appointed the honorary chair of the International Year of the Child. Durham mayor Wade Cavin signs the proclamation. Other members present are Rev. W.E. Easley, the chairman of the committee, and Dan Hudgins, the social services director for Durham County. (*Carolina Times.*)

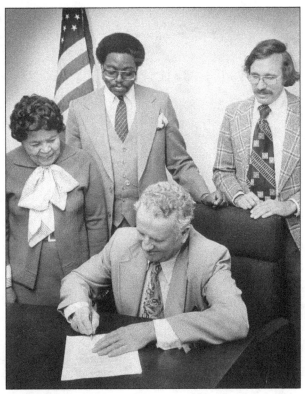

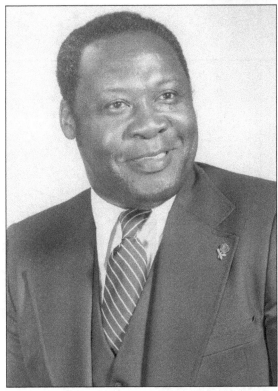

In 1970, Joseph W. Becton Jr. (1932–2013), became the first executive director of the City of Durham Human Relations Commission, and in that capacity, was integral in seeking equal opportunities for African Americans in education, employment, housing, and public accommodations, and the enactment of the Civil Rights Act of 1964, 1968, and 1972. Also, as a member of the WTVD Advisory Committee, where he served as chairman from 1971 to 1977, he helped to pioneer diversity for the local station. (Edna Becton.)

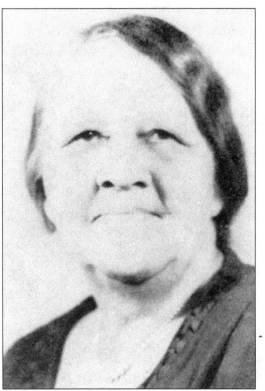

Pearl Bell Walker Page (1885–1973) came to Durham in 1907 and later married James L. Page, a cafe owner and produce merchant. She was one of Fayetteville Street's oldest residents and an inspiration to her children as they carried on the J.L. Page and Sons Grocery on Fayetteville Street. She was an active member of White Rock Baptist Church for 66 years when it was located in the 600 block of Fayetteville Street. (Andre D. Vann.)

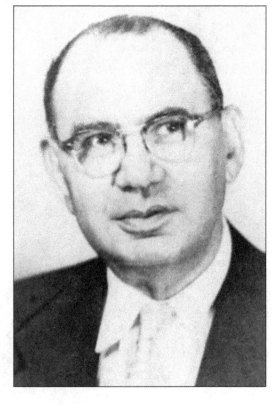

William Madison Rich (1889–1967) came to Durham in 1934 as director of Lincoln Hospital, where he served until retirement in 1959. Under his leadership, the hospital was enlarged from 90 beds to a modern facility of 125 beds with a budget of $450,000. Rich was also a charter member and first African American appointed to the North Carolina Medical Care Commission in 1949. (Andre D. Vann.)

Carolyn N. Henderson, a retired associate director of education services at Durham Regional Hospital and Duke University Health System, has been an advocate for healthcare in the Durham community. She is a proud alumna of Lincoln Hospital School of Nursing and a graduate of its last class in 1971. (Carolyn N. Henderson.)

Polly Whitted, an administrative assistant at the Hayti Heritage Center, has been a link to the Durham community. She has been a resource and chief scheduler for those seeking space for weddings, programs, and community events in the Hayti Heritage Center. (Polly Whitted.)

Dr. James and Mary Duke Biddle Trent Semans were members of the third generation of the Duke family and held strong ties to Lincoln Hospital and other community projects. (*Carolina Times*.)

Carlin Graham (1909–1961) was a noted photographer in the African American community and a member of the photography staff at Duke Hospital until 1950, when he accepted a post at the Veterans Hospital at the Tuskegee Institute. (Andre D. Vann.)

Five

DURHAM'S AFRICAN AMERICAN FIRSTS

John C. Scarborough Sr. (1877–1972), top, and son J.C. "Johnnie" and daughter-in-law Hattie S. Scarborough are shown in this calendar given out to Durham residents. Scarborough Sr. was "dean" of black funeral directors in Durham and North Carolina. He graduated from Renouard and came to Durham in 1906, where he became the first African American licensed embalmer in North Carolina. In 1906, the Scarborough-Hargett firm was located in the Five Points area, and in 1925, the company moved to 522 E. Pettigrew Street for 40 years. As a result of urban renewal, the firm was moved temporarily to 919 Fayetteville Street for five years until a modern structure, dedicated in 1974, was erected. Scarborough Sr. was married to Daisy E. Hargett Scarborough and later to Clydie Q. Scarborough. (Queenie B. and J.C. "Skeepie" Scarborough III.)

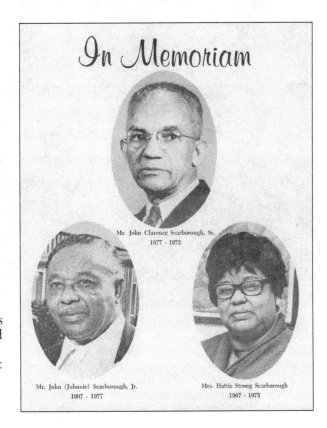

In Memoriam

Mr. John Clarence Scarborough, Sr.
1877 - 1972

Mr. John (Johnnie) Scarborough, Jr.
1907 - 1977

Mrs. Hattie Strong Scarborough
1907 - 1973

Dr. Alexander Sterling Hunter (1883–1957), a native of Wilmington, North Carolina, was the son of Rev. George W. and Ada Hunter, who served as pastor of St. Joseph AME Church. Alexander holds the distinction of being the first African American to practice dentistry in Durham, having opened his practice in 1909 and serving for 48 years. He received his education at Kittrell College and Meharry Medical College. (Andre D. Vann.)

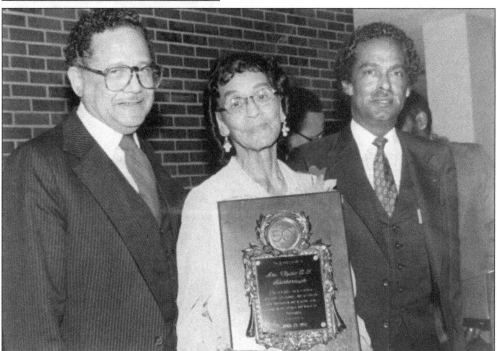

F.V. "Pete" Allison (left), president of the board of directors of the Scarborough Nursery School, is pictured with Clydie F. Scarborough (1899–1989, center) and Rep. H.M. "Mickey" Michaux Jr., master of ceremonies, at a banquet in 1982 that recognized Scarborough for over 50 years of service as the first director of the Daisy Scarborough Nursery School. The school cared for an estimated 10,000 children in the Durham vicinity. Daisy's husband, J.C. Scarborough Sr., purchased the old Lincoln Hospital in 1925 and renovated it for use as a nursery. The nursery school was established in 1932, and kindergarten classes were run by Clydie Scarborough in 1938. It is North Carolina's oldest nursery school and the first to be licensed by the state. (Queenie B. and J.C. "Skeepie" Scarborough III.)

Ernestine Hargett Scarborough Bynum (1911–1996), born in Durham and the daughter of J.C. and Daisy E. Hargett Scarborough Sr., graduated from high school at St. Augustine's College and from North Carolina College for Negroes. She initially served as a social worker in New York City and returned to Durham in 1959 to assist her father and brother in the funeral home business after enrolling in the Atlanta School of Mortuary Science. She became the first licensed African American woman embalmer in North Carolina. In 1972, she was elected the first woman president of the Funeral Directors and Morticians Association of North Carolina. (Queenie B. and J.C. "Skeepie" Scarborough III.)

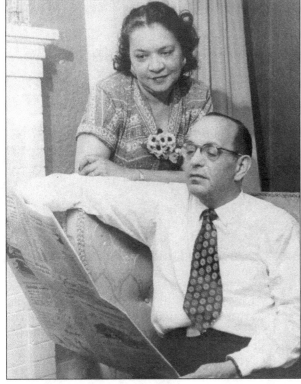

Rencher N. Harris (1900–1965), seen here with his wife, Plassie Williams Harris (1902–1994), came to Durham in 1921 and holds the distinction of being the first African American elected to the Durham City Council in 1953, serving until 1957. In 1958, Harris was appointed by the Durham City Council to the board of education and resigned from the Durham City Board of Education in 1962 due to ill health; he urged the board to name another African American to his vacant seat. The R.N. Harris Elementary School in Durham is named in his honor. (Andre D. Vann.)

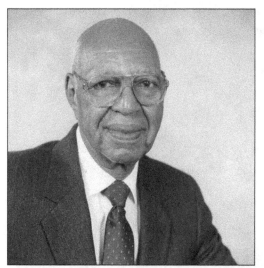

John S. "Shag" Stewart (1910–1995), a banker, civic, and political leader, is a native of Atlanta who came to Durham in 1935 as a salesman for North Carolina Mutual Life Insurance Company; he later served as executive secretary, and later, president of Mutual Savings and Loan Company, where he remained until retirement in 1978. He became the second African American on the Durham City Council in 1957 and served through 1973. He served as the first African American mayor pro temp from 1971 to 1973, having been nominated unanimously by vote of the council. He was also among the first two African Americans to join the Tobaccoland Kiwanis Club in 1969. (James A. Stewart Jr.)

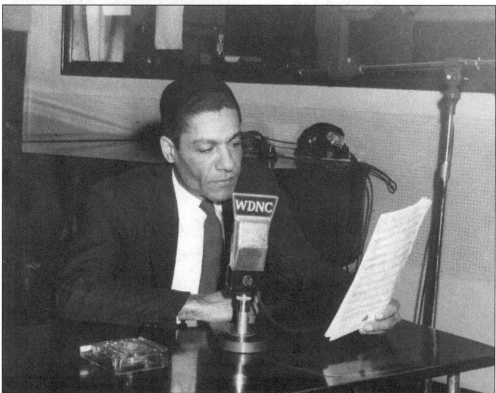

Norfleet Whitted (1905–1985), a radio pioneer and community leader, was CBS's first African American announcer and the first to handle coast-to-coast broadcasts for a national network. He produced African American programming that attracted both local and national attention, including A Study in Brown, a 30-minute program that featured black artists that went national in 1947. Whitted also narrated and produced the Southern Plantation musical series and Driftwood, a poetry series. He also directed another coast-to-coast show, Wings Over Jordan, which was broadcast over CBS for a 13-week period. He is interred in Beechwood Cemetery. (Alex M. Rivera Estate/Dr. Eric Rivera.)

Dr. William A. Cleland (1907–2001) came to Durham in 1914, received undergraduate and medical degrees from Howard University, and interned at Freedmen's Hospital in Washington, DC. Cleland returned to Durham in 1935 and was awarded a Rosenwald Fund fellowship from 1936 to 1937. Upon return, he became Durham's first African American pediatrician and handled pediatric services at Lincoln Hospital. During his early years, he charged $1 for an office visit but sometimes only received 25¢, as some parents were only able to pay the fee in installments. He was one of the pioneer African American physicians admitted onto the medical staff of Watts Hospital and faculty of Duke University School of Medicine in 1968. He retired from clinical practice in 1978. (Andre D. Vann.)

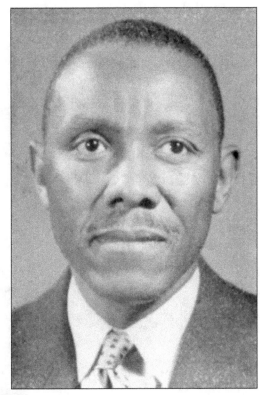

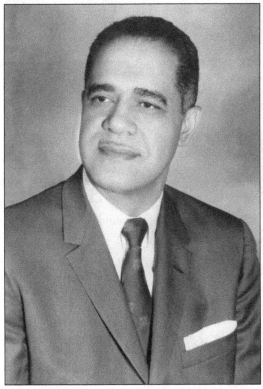

Dr. Charles D. Watts (1917–2004), a Morehouse College and Howard University College of Medicine graduate, practiced in Durham from 1950 to 1988. He was director of student health services at North Carolina College at Durham and medical director and vice president of North Carolina Mutual Life Insurance Company and member of the board of directors. In 1950, Watts became the first African American board certified surgeon in North Carolina by the American Board of Surgery, American College of Surgeons. He was the founder of the Lincoln Community Health Center and served as its first director. (North Carolina Mutual Life Insurance Company.)

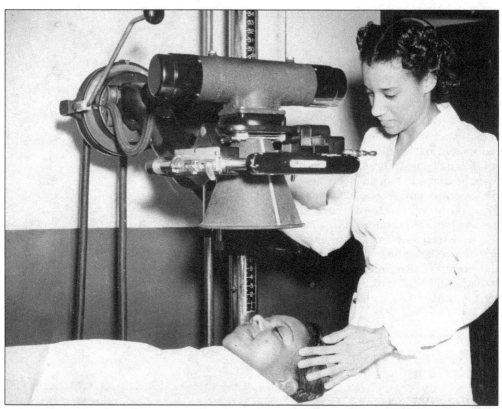

Margaret Kennedy Goodwin, a third-generation resident of Durham with ties to the founders of North Carolina Mutual Life Insurance Company and Lincoln Hospital, joined Lincoln Hospital in 1943 and retired in 1983. In 1947, she became the first African American female X-ray technician certified by the American Society for X-ray Technicians and the first African American member of the North Carolina Society of X-ray (Radiologic Technologists) Technicians; she later served as its first black president from 1957 until 1958. (Marsha Goodwin Kee.)

Upon the death of her husband, Charles J. Ingram, Bernice Hicks Ingram (1907–1996) assumed the duties of president and manager of Dunbar Realty and Insurance Company from 1939 to 1989. She became the first African American female owner and operator of a real estate company in Durham. In 1950, she became the first African American woman registrar appointed to the W.G. Pearson School Precinct by the Durham County Board of Elections. (Dr. E. Lavonia I. Allison.)

Editor Louis Austin (1898–1971), a native of Enfield, North Carolina, came to Durham to attend the National Training School, which he graduated from in 1921. Upon receiving an education, he began working as an insurance agent for the North Carolina Mutual Life Insurance Company until 1926, when he founded and became the first editor of the militant *Carolina Times* newspaper. His newspaper office became the headquarters of numerous civil rights organizations, including the Durham Committee on the Affairs of Black People. The motto of the newspaper, *Truth Unbridled*, reflected Austin's commitment to serve God, man, and the black community. (Kenneth Edmonds.)

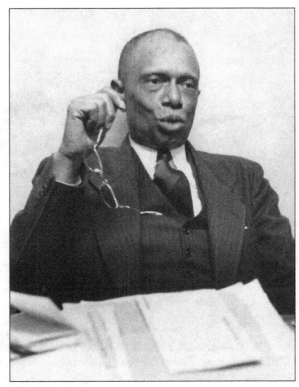

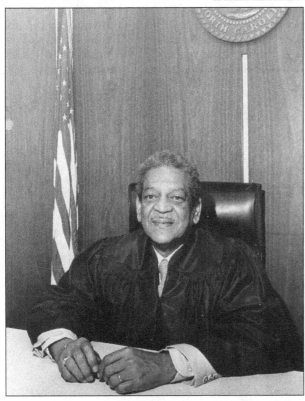

Judge William Gaston Pearson II (1914–1985) was born to James L. and Mary Bailey Pearson and graduated from North Carolina College for Negroes and its law school. He served in the US Air Corps and headed several businesses before he opened the law firm Pearson, Malone, Johnson & DeJarmon. He was also cooperating counsel with the NAACP Legal Defense and Educational Fund. In 1977, Pearson was appointed the first African American judge on the district court bench in Durham County by Gov. James B. Hunt to the 14th Judicial District and was elected in the 1978 and 1982 primaries. He retired in 1984 and served as an emergency fill-in judge in Durham County and surrounding counties. (Andre D. Vann.)

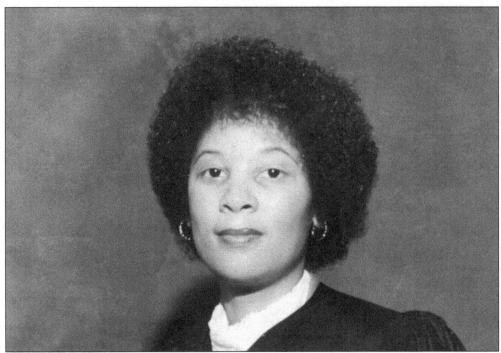

District court judge Karen Bethea Galloway Shields was born in Method, North Carolina, and graduated from East Carolina University and Duke University Law School in 1974. She was among the first African American women to enter and graduate. On the day she passed the North Carolina bar exam in 1974, she was named co-counsel in the Joan Little case, for which she was noted for her diligence in securing Little's freedom. In 1979, Shields was appointed by North Carolina governor James B. Hunt as the first African American woman to serve as a judge in the state's 14th Judicial District (Durham). She left the bench in 1986 as a result of illness, but continues to practice in her own firm. (Karen Bethea Galloway Shields.)

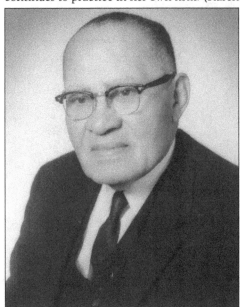

Meredith Hugh "Tommy" Thompson (1898–1973) was the first African American president of the Durham County Bar Association of the 14th Judicial District. He was recognized in 1973 for his 50 years of service to the legal profession. A graduate of Syracuse University, he served in the US Army, where he was a lieutenant during World War I. In 1923, upon graduating from Howard University Law School, where he was a classmate of US Supreme Court justice Thurgood Marshall, he came to Durham to practice law. (James M. Turner.)

Rep. H.M. "Mickey" Michaux, a second-generation resident of Durham, received his undergraduate and law degrees with honors in 1964 from North Carolina Central University. He has been both a practicing real estate broker and attorney for over 50 years. In 1972, he successfully ran for a seat in the North Carolina General Assembly and was elected the first African American from Durham County to serve. Michaux was reelected in 1974 but was soon appointed by Pres. Jimmy Carter to be the US attorney for the Middle District of North Carolina. He was reelected in 1984, for a total of 20 terms, and is the "dean" and longest serving African American and Democrat in the North Carolina General Assembly. The H.M. Michaux Jr. School of Education Building at NCCU is named in his honor. (Mickey and June Michaux.)

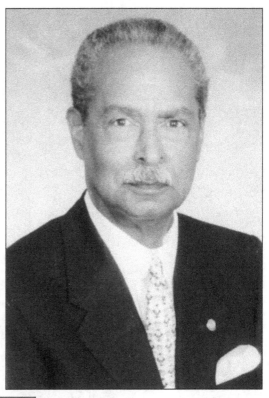

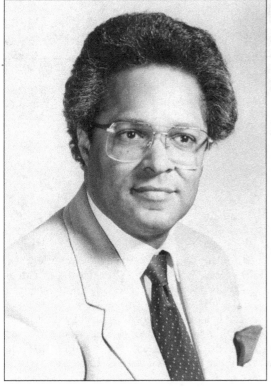

Attorney Eric Coates Michaux is a second-generation resident of Durham. He was among the first African American students to attend Duke Law School and later, along with his brother Representative Michaux, integrated the North Carolina Bar Association. Michaux was the only African American attorney in the Air Force in Vietnam. In 1973, he was appointed assistant district attorney for the 14th Solicitorial District, and in 1974, he became the first African American to serve on the state licensing board for lawyers in North Carolina. (Eric C. and Della Michaux.)

Asa Timothy Spaulding (1902–1990) came to Durham at the urging of Dr. Aaron M. Moore to receive a secondary education in 1918. He graduated from the National Training School (now North Carolina Central University) in 1923, and began working for North Carolina Mutual Life Insurance Company. He attended New York University and the University of Michigan, where he received a master's in mathematics and actuarial science. Spaulding later became the fifth president of North Carolina Mutual Life Insurance Company. He was the first black actuary in the United States. (North Carolina Mutual Life Insurance Company.)

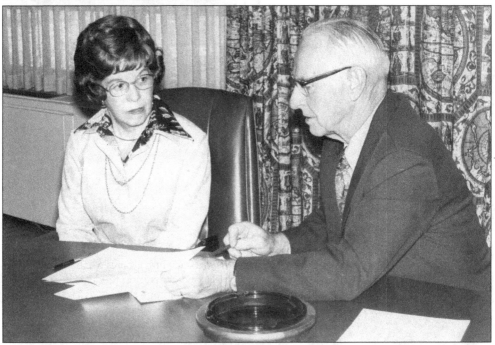

Elna Bridgeforth Spaulding (1909–2007) is briefed on her new duties as a county commissioner by Commissioner Dewey Scarboro in 1974. As a Talladega College graduate, she came to Durham in 1930 to teach in the Durham city schools. She taught for a year before accepting a post as head of the music department at Winston-Salem Teachers College. She later married Asa T. Spaulding in 1933 and became actively involved in various civic, religious, educational, and political activities in Durham. Spaulding holds the distinction of being the first African American woman elected to the Durham County Board of Commissioners in 1974, serving for a decade until 1984. She was the first president of Women-In-Action for the Prevention of Violence and Its Causes, which was founded in 1968. (*Carolina Times*.)

Attorney William A. "Billy" Marsh II was born and raised in Durham and graduated from North Carolina College and its school of law. He served as the first African American chair of the Durham County Board of Elections, the first in the state of North Carolina. He later served as the first African American chairman of the North Carolina State Board of Elections. He was a key figure in school desegregation cases in Durham, Montgomery, Caswell, Warren, Currituck, and Greene Counties. In 1957, he was legal counsel to the "Royal Ice Cream Seven." He served as general counsel to the Mechanics and Farmers Bank, Mutual Community Savings Bank, and UDI Community Development Corporation. (Judge William A. "Drew" Marsh III.)

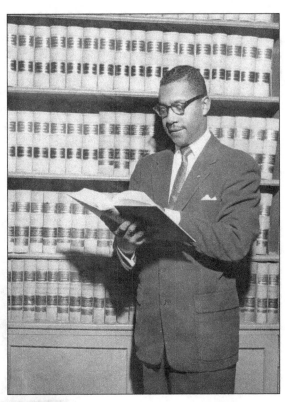

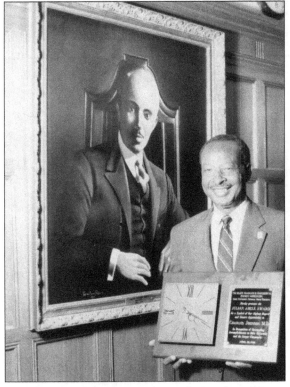

Dr. Charles Johnson is a professor of medicine emeritus in endocrinology, metabolism, and nutrition at Duke University and a Howard University School of Medicine alumnus. He spent his residency at Lincoln Hospital and Duke Hospital. He was the first African American to hold a fellowship in endocrinology at Duke and was recruited to join the Duke School of Medicine in 1970. He became the first African American appointed to the school's medical faculty. As a faculty member, he served as special assistant to Duke's chancellor of health affairs. He served as the 89th president of the National Medical Association, from 1990 to 1991. (Dr. Charles Johnson.)

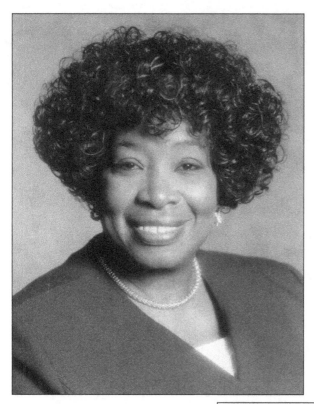

Sen. Mary Jeanne Hopkins Lucas (1935–2007) is a native of Durham and graduate of Hillside High School and North Carolina Central University. She was an educator and administrator in Durham Public Schools from 1957 to 1993. On August 3, 1993, she was appointed to represent the 13th Senatorial District, becoming the first and only African American woman in Durham to do so and North Carolina's first African American female state senator. She was elected for seven consecutive terms as state senator, five terms for the 13th District representing Durham County, and two terms representing the 20th District. Known in the senate as "Queen Jean," she worked across party lines and became the first African American senate majority whip. Lucas Middle School in Durham County is co-named in her honor. (William "Bill" Lucas.)

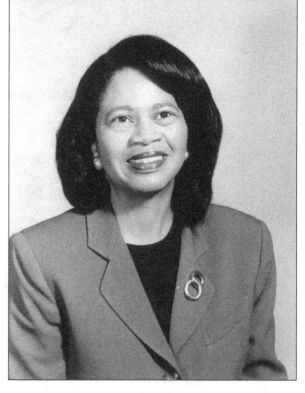

Dr. Beverly Washington Jones, a retired vice chancellor for Academic Affairs & Provost at North Carolina Central University, is a third-generation resident of Durham and attended Hillside and North Carolina Central University, where she received bachelor's and master's degrees. She became the first African American woman to obtain a doctorate in history from the University of North Carolina at Chapel Hill. (Dr. Beverly Washington Jones.)

Lee W. Smith Jr. was the longest-serving executive director of the John Avery Boys and Girls Club, from 1945 to 1983. Under his direction, the club provided a wide range of after-school recreational and learning activities for youth in the Durham community. He was a past member of the Boys' Clubs of America's national board of directors and was the recipient of both the Bronze Keystone with a silver star and the Distinguished Service Award. He was a 1942 graduate of the North Carolina College for Negroes (now NCCU). (Kris Mayfield.)

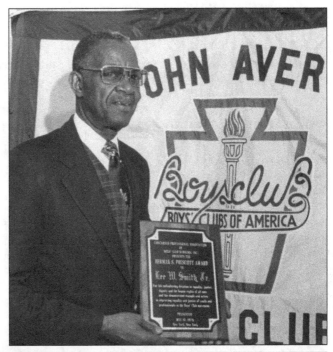

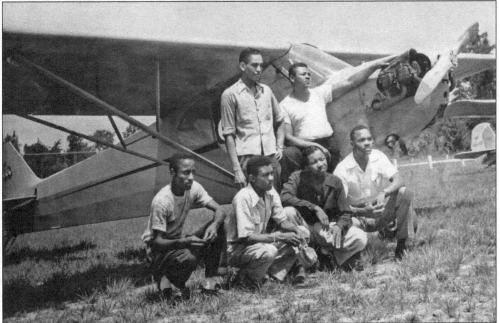

This 1945 image by noted photojournalist Alex M. Rivera shows members of Durham's first group of African American aviation pioneers who, after World War II, were determined to learn to fly. Thanks to the GI bill, all became certified, licensed pilots who learned to fly on an air strip where present-day Northern High School is located. The Bronze Wings Flying Club lasted three years and sought to foster awareness and interest in youth interested in aviation certification and experience. From left to right are (kneeling) J. Clifton Thompson, E. Leon Goldston, Burleigh R. Page, and John R. Bridges; (standing) Samuel Toomer and Nathaniel Adams. (E. Leon Goldston.)

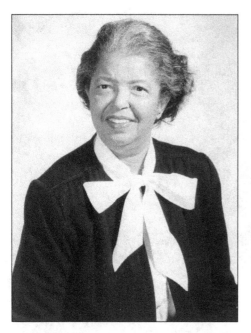

Vivian Austin Edmonds (1927–2008), the editor, owner, and publisher of the *Carolina Times*, was a third-generation native of Durham and the daughter of Louis and Stella Walker Austin. Edmonds assumed leadership of the paper after the death of her father in 1971. She graduated from NCCU in 1948 and spent several years working with her father before going back to graduate school. She was formerly a guidance counselor for the Chapel Hill–Carrboro city schools before assuming day-to-day management of the *Times*. Under her leadership, the paper consisted of a full-time editor and a staff of four. When a fire destroyed the offices, she moved into temporary headquarters and the paper never missed an edition. Edmonds was inducted into the North Carolina Journalism Hall of Fame in 1988 and was awarded an honorary doctorate from her alma mater, North Carolina Central University. (Kenneth Edmonds/the *Carolina Times*.)

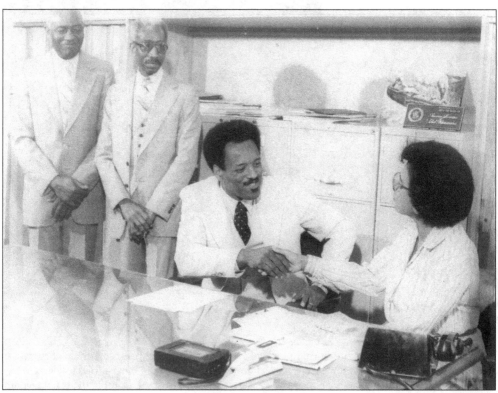

From left to right are John Lennon, Dr. Thomas Bass, Dr. Cleveland Hammonds (1936–2010), and Josephine Dobbs Clement as Hammonds accepts the post of superintendent of Durham city schools on July 2, 1979. Hammonds was Durham's first African American superintendent—as well as the first in North Carolina—and the first black superintendent of the year. (Arthur John Clement.)

Rev. Dr. Vernon E. Brown (1908–2008) served as pastor of Gethsemane Baptist Church and as the first black court bailiff in Durham County history. (*Carolina Times.*)

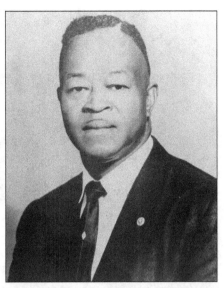

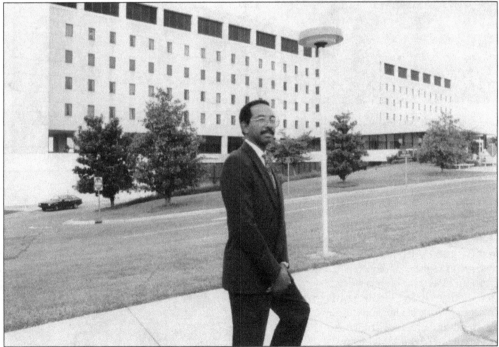

Larry T. Suitt Sr. (1940–2015) was a native of Durham and graduate of Hillside High School and North Carolina Central University. He served in the US Army during the Vietnam War and was honorably discharged in 1965. Suitt attended several hospital administration programs at the University of Chicago and Duke University. In 1978, he was certified by the American College of Healthcare Executives. He joined the Lincoln Hospital administrative staff as a comptroller in 1966 and 1968; he became administrator of Lincoln Hospital and served until 1976. After the merger of Lincoln and Watts Hospitals, he helped facilitate the building and opening of Durham County General Hospital. In 1987, he became the first African American chief operating officer and first vice president of Durham Regional Hospital and the first in the state. He served for 33 years until his retirement in 1999. (Gwen Taylor Suitt.)

Willie Covington was elected register of deeds in 1996 and became the first African American to hold the position, which he did until his retirement in 2016. He was instrumental in digitizing and making countless records and materials available for public consumption. (Willie Covington and Dr. Jerry Head.)

Sharon Davis was sworn in as the first African American female to serve as register of deeds in Durham County. She has served in the office since 1988, working as deputy, work leader, supervisor, assistant, and chief assistant. She is a graduate of the University of North Carolina at Chapel Hill and received a law degree from NCCU School of Law in 1982. She was elected in the 2016 Democratic primary with 90 percent of the vote, and was recommended by the Durham County Democratic Party executive committee. (Sharon A. Davis and Dr. Jerry Head.)

Dr. Robert Edward Dawson Sr. (1918–2008) moved to Durham in 1946 as the first eye, ears, nose, and throat doctor at Lincoln Hospital. His year-long fellowship with Dr. Banks Anderson helped him to qualify for his specialty boards. He was the first board certified African American diplomat of the American Board of Ophthalmology to practice in North Carolina. At Lincoln, he served as chief of ophthalmology and as medical director; additionally, he was attending staff at Watts Hospital and Durham Regional Hospital, where he was vice president of staff, and later, a member of the board of trustees. Dawson served as the 79th president of the National Medical Association. (Robert Dawson Jr.)

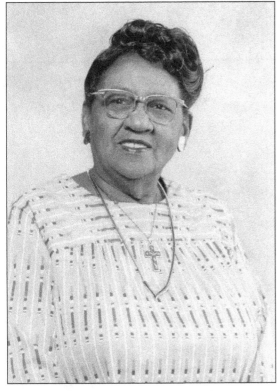

Dr. Helen G. Edmonds (1911–1995), a scholar, historian, and civic leader, spent 35 years (from (1941 to 1977) at North Carolina Central University in such capacities as advisor to the drama club, chair of the Department of History and Social Science, dean of the Graduate School of Arts and Sciences, member of the Interim Committee for the Administration of the College, and distinguished professor of history. She was the first African American woman to become a dean of a graduate school of arts and sciences in the United States and the first black female to second the nomination of a president of the United States. (Rebecca Palmer Edmonds.)

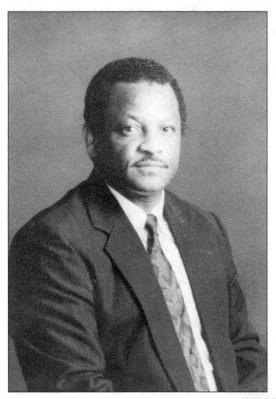

Durham's first black mayor, Chester Jenkins (1938–2009), was born in Durham County and graduated from Merrick-Moore High School. He was elected to the Durham City Council for eight years and was elected Durham's first African American mayor in 1989 to 1991. He fought for the passage of the Minority/Women Business Enterprises Ordinance, the construction of the downtown civic center, and the acquisition of the local bus system from Duke Power Company. Jenkins's efforts helped to keep the Durham Bulls baseball team in Durham, which led to the construction of the new Durham Bulls Stadium. He also led the effort to renovate the Carolina Theatre and the construction of the Campus Hill/Erwin Holmes Recreation Center. (Leola Hall Jenkins.)

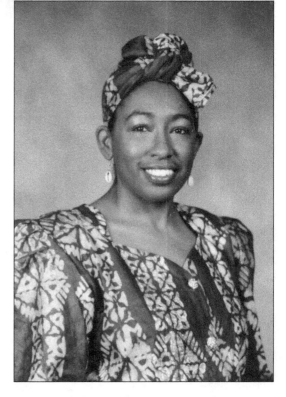

Attorney Mary E. Wright joined the faculty at North Carolina Central University School of Law in 1985, served as assistant dean for the day program (1989–1990), and was appointed interim dean of the law school in 1990. In 1991, she became the first African American female to serve as dean of the NCCU School of Law. She was also one of only two African American females in the country serving as law school deans at that time. In 1994, Dean Wright returned to the classroom and resumed full-time teaching responsibilities at the law school. (Mary E. Wright.)

Six

EDUCATION, POLITICS, AND CIVIL RIGHTS

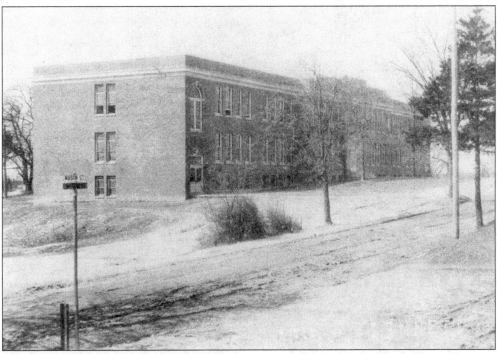

Hillside Park High School, shown in 1922, opened on Monday, September 18, 1922, as the first high school and largest school for African Americans in Durham, with Dr. William Gaston "W.G." Pearson as the first principal. The 20-room building and auditorium, which rests on four acres, is a Classic Revival–style brick building located at the corner of Pine (South Roxboro) and Umstead Streets; it replaced the J.A. Whitted School that burned on the site. It was renamed Hillside High School in 1941 and J.A. Whitted Elementary School in 1950, followed by J.A. Whitted Junior High School in the 1950s. In 1950, Hillside High School moved to Whitted, and J.A. Whitted occupied the Hillside space. In 2013, it was listed in the National Register of Historic Places. (North Carolina State Archives.)

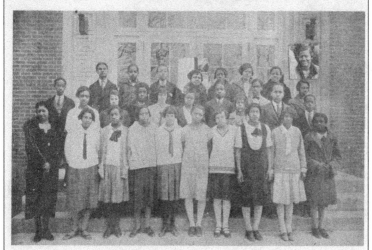

CLASS OF 1927
HILLSIDE HIGH SCHOOL

BOTTOM ROW, L TO R: Mrs. Omeda R. Livingstone, Advisor, Miss Geneva Richardson, Mrs. Minerva Evans, Mrs. Alice Jones, Mrs. Martha Dooms, Mrs. Josephine DeNard, Mrs. Nina Watts, Mrs. Margaret Allen, Miss Nannie Green (deceased), Mrs. Katherine Gill.

SECOND ROW, L TO R: Charles Davis, Mrs. Lola Solice, Miss Angeline Spaulding (deceased) Miss Listerine Fuller, Mrs. Isadora Brennan, Paul Fisher, Miss Annie Strudwick (deceased) Charles Grice, Thebaud Jeffers, Arnetta Davis, Maryland Jeffries.

THIRD ROW, Edward Avant, Frank Moore, Frank Burnett, Miss Annie Mae Trice (deceased) Mrs. Pearl George, Mrs. Margaret Wright, Mrs. Margaret Fuller, Inset – Miss Ellen Warren.

Members of the Hillside High School class of 1927 pose in front of the school. At far left in the first row is class advisor Omeda Reynolds Livingstone. (Andre D. Vann.)

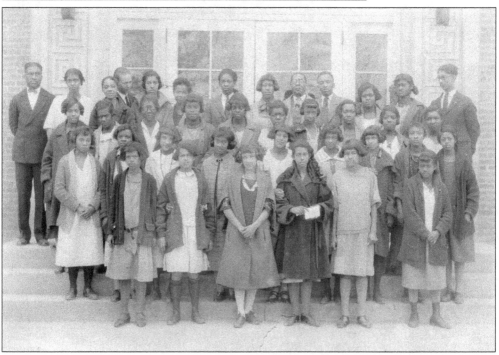

Members of the Hillside High School are pictured on the steps of the school in 1926. In the first row, second from left, is Pauli Murray, who went on to become one of the most noted activists and civil rights leaders of the 20th century. In the back row, wearing glasses and a vest, is principal W.G. Pearson. (Andre D. Vann.)

78

This image appeared in a 1938 city directory and recognized four pioneers in the field of business in the city of Durham: Dr. A.M. Moore, John Merrick, C.C. Spaulding, and W.G. Pearson. (Andre D. Vann.)

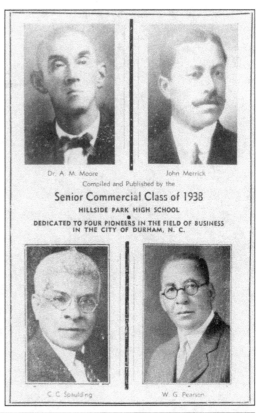

Dr. A. M. Moore John Merrick

Compiled and Published by the

Senior Commercial Class of 1938

HILLSIDE PARK HIGH SCHOOL

DEDICATED TO FOUR PIONEERS IN THE FIELD OF BUSINESS
IN THE CITY OF DURHAM, N. C.

C. C. Spaulding W. G. Pearson

Students at Hillside Park High School pose in front of the school in the late 1930s with trophies. At far left in the first row is local mortician Grover T. Burthey, who taught art at Hillside after graduation and later opened Burthey's Funeral Service on Fayetteville Street. (Catherine B. Mangum.)

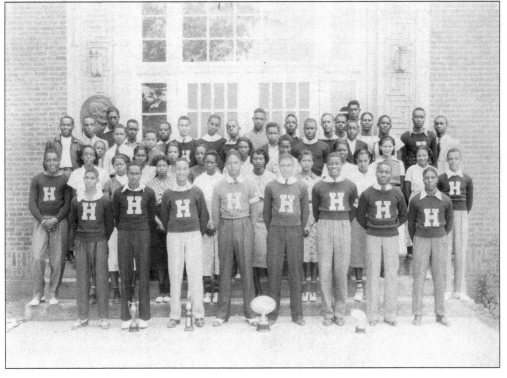

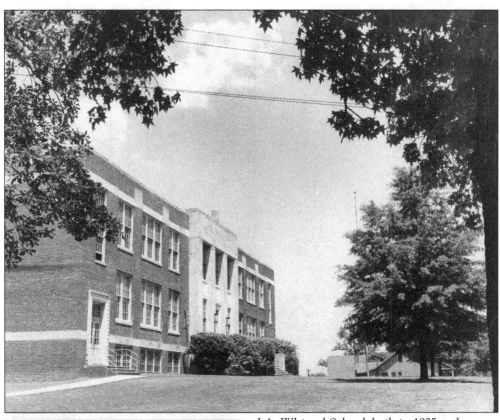

J.A. Whitted School, built in 1935 and seen here in the 1950s, served as a model high school for African American students in Durham. The Art Deco/Neoclassical masonry structure included an auditorium, cafeteria, classrooms, gymnasium, and auto shop that was formerly located at 1900 Concord Street between East Lawson Street and Formosa Avenue in 1950. A classroom annex was added in 1962. The library was constructed in 1966, and a band room followed in 1975. The structure was demolished in 2003, and NCCU built its Mary Townes Science Complex on the site. (Mamie V. Alston.)

"Professor" Frank Howard Alston (1918–1989), a Durham native and community figure, is remembered fondly as a World War II veteran and teacher, assistant principal, and dean of boys at Hillside High School, where he served for 33 years. The F. Howard Alston/Russell Memorial Child Development Center at his church is named in his honor. (Mamie V. Alston.)

A young Catherine Burnett is seated at center in this car participating in the Hillside High School homecoming parade in 1959. (Catherine Burnett Mangum.)

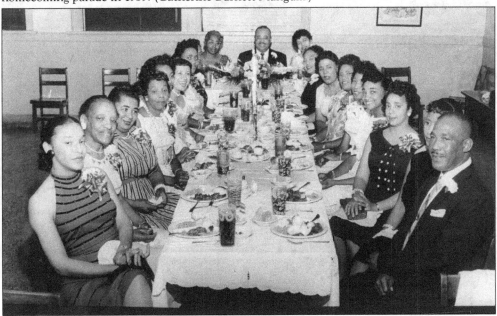

A Lyon Park School faculty dinner is pictured here around 1955. Among those pictured are, in unknown order, Mary L. Stephens, Mary Grant, Isabelle Harden, A. Marie Faulk, Annie Cobb, Nanny Grigsby, Frank Burnett (principal, at head of table), Evelyn Kennedy, Ruby Grissom, Bessie McLaurin, Mamie Alston, Alma Bennett, and Adolph Coward (far right). (Catherine B. Mangum.)

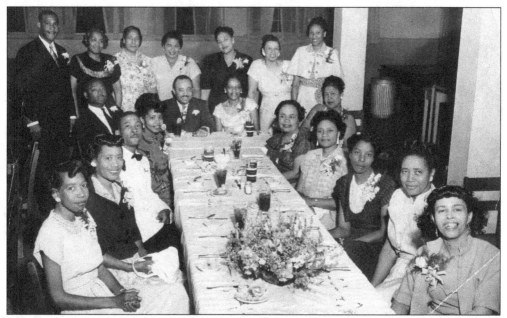

Another Lyon Park School faculty dinner is seen here around 1950. Among those pictured are Virginia Bivens, Alma Bennett, a Mr. Kearney, William Battle, principal Frank Burnett, Mary L. Stephens, Bessie McLaurin, Isabelle Harden, Annie Cobb, Evelyn W. Kennedy, Adolph Coward, Nanny Grigsby, Rosa Artis, Mary Grant, Ruby Grissom, A. Marie Faulk, and Verdelle Johnston. (Catherine B. Mangum.)

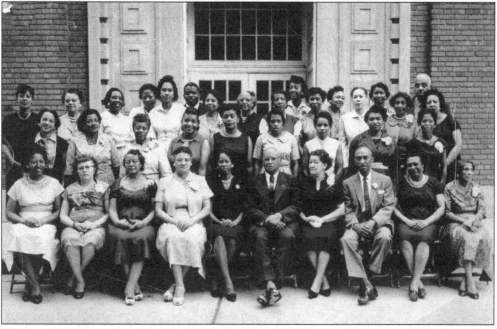

This late 1950s image shows members of the faculty at W.G. Pearson Elementary School seated in front of the school. Principal Nathaniel A. "N.A." Cheek is seated in the first row, sixth from the left. He was appointed principal at W.G. Pearson Elementary in 1949 and served until retirement in 1961. (Catherine B. Mangum.)

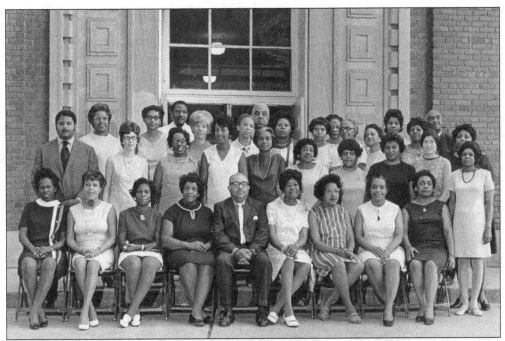

Members of the faculty at W.G. Pearson Elementary School are pictured in front of the school building in the 1960s. Frank G. Burnett, who served as principal at Pearson from 1961 until his retirement in 1975, is in the first row, fifth from the left. (Catherine B. Mangum.)

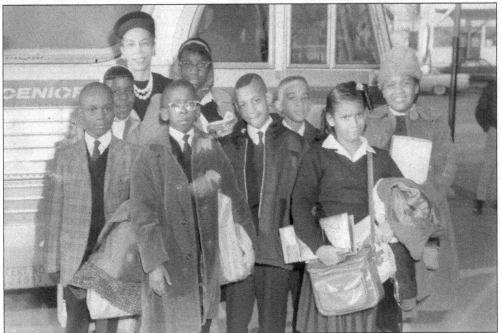

W.G. Pearson Elementary School teacher Bernadine Bailey, in the back row at far left, is shown with eight students who went to Columbia University to attend the Columbia Press Association meeting in New York. The students also toured New York. In the first row at far right is Connie Jo White; seven other fifth-graders also made the journey. (Catherine B. Mangum.)

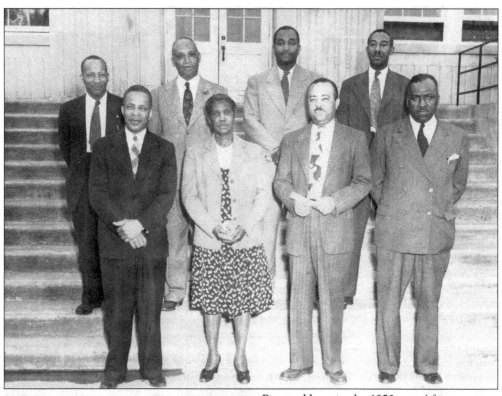

Pictured here in the 1950s are African American principals in Durham; from left to right are (first row) John W. Davidson, Cora T. Russell, Frank G. Burnett, and F.D. Marshall; (second row) James M. Schooler Jr., Nathaniel A. Cheek, Henry A. Hill, and unidentified. (Catherine B. Mangum.)

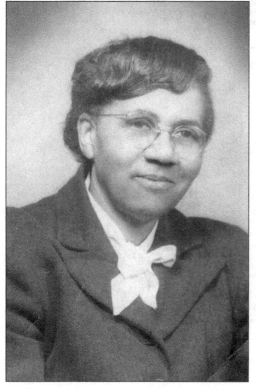

Mamie Grandy Dawson (1894–1972) served as principal at rural Stagville Elementary School and later joined the faculty of Little River County School, where she worked until her retirement. She was an active member of St. Joseph AME Church. (Clem Grandy.)

Mary Fannie Bailey Pearson (1884–1966), born in Durham County, was educated in the local public schools and was a 1900 graduate of the James A. Whitted School. She attended Hampton Institute and taught in Durham schools for seven years, primarily as a first-grade teacher. In 1906, she married James L. Pearson, secretary of the Royal Knights of King David, and began a life dedicated to her family and St. Joseph AME Church. She held memberships in the Schubert-Shakespearean Club and the Twentieth Century Club, which both promoted civic and cultural interests. She was mother to Minnie Willette, Louise, James L. Jr., and William G. Pearson II. (James M. Turner.)

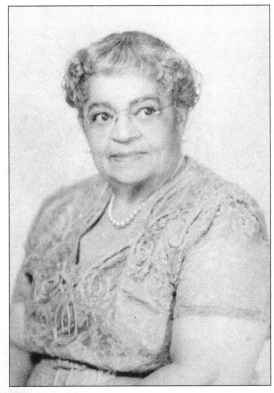

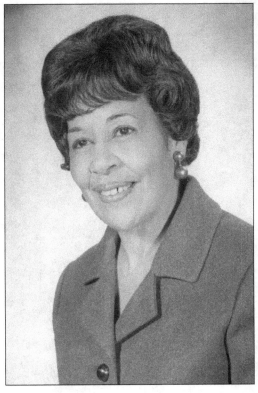

Minnie Willette Pearson Turner Spaulding (1907–1985) was born in Durham and was a graduate of Hillside Park High School. After graduating from Howard University in 1928, she married Dr. Israel E. Turner Sr. They were the parents of Israel E. Jr., Eugene Pearson, and James M. Turner. She was a teacher at Hillside High School from 1928 until 1956. Dr. Turner died in 1952. In 1956, Minnie joined the English faculty at North Carolina College (now North Carolina Central University), where she remained until she retired in 1973 as director of the University Honors Program. In 1960, she married attorney Charles Clinton Spaulding Jr. She was an active member of St. Joseph AME Church and served on numerous civic boards throughout Durham. She also served as president of National Barristers Wives. (James M. Turner.)

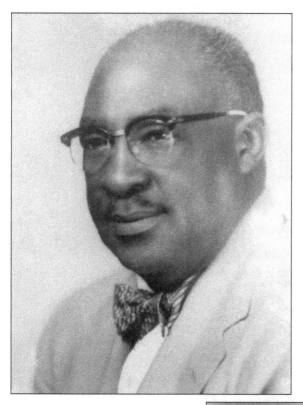

Civil rights attorney Caswell Jerry "C.J." Gates (1895–1970) was a pioneer civil rights lawyer who came to Durham in 1927. He practiced law in Durham for 43 years and was affectionately called "Judge" by his associates. In 1950, he was among the first African Americans in Durham and North Carolina to serve as a delegate and attend the North Carolina State Democratic Convention. (Andre D. Vann.)

Civil rights attorney Edward K. Avant (1910–1972) was a native of New Bern, North Carolina, and came to Durham in 1922 when his parents, Rev. William G. and Jane Dudley Avant, accepted the pastorate of Pine Street Presbyterian Church. Edward was a graduate of Johnson C. Smith University and Howard University Law School, as well as a World War II veteran and a partner in the Bumphass, Belcher, & Avant Law Firm. In 1938, he and attorney C.J. Gates argued a noted case on behalf of Ellen Harris, who was arrested in Durham because she refused to move to the back of a bus and give her seat to a white man. When she was convicted, she appealed to the North Carolina State Supreme Court. Avant and Gates successfully argued for the decision to be reversed. (*Carolina Times*.)

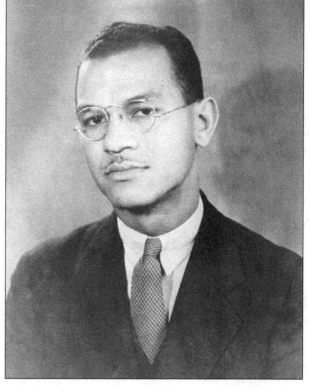

Members of the first executive committee of the Durham Committee on Negro Affairs, which formed in 1935, are pictured here. C.C. Spaulding, president of North Carolina Mutual Life Insurance Company, sent out a letter inviting "Negro" citizens to meet at the Algonquin Tennis Club House for the purpose of discussing life in Durham. It is reported that 150 citizens of all walks of life assembled on August 15, 1935. It was agreed that an organization was necessary to confront economic, educational, political, civic, and social welfare issues. Now in its 82nd year, the organization is known as the Durham Committee on the Affairs of Black People. (*Carolina Times.*)

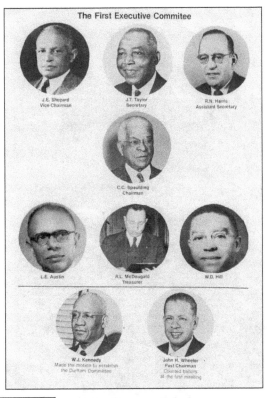

Attorney Floyd B. McKissick Sr. (1922–1991) came to Durham to attend North Carolina College for Negroes, and in 1948, led a picket of the state legislature protesting unequal facilities at the North Carolina College Law School and was the first "Negro" to desegregate the University of North Carolina Law School. He returned to NCC Law School and, after graduation, practiced in Durham. Beginning in the 1950s, he was an advisor to the Durham Youth and College NAACP chapters and was seen as "militant" by the national body. He served as chairman of the Congress of Racial Equality (CORE) and was founder of Soul City, North Carolina, the only freestanding new community financed under Housing and Urban Development authority during the late 1960s. (Vivian McCoy and Senator Floyd B. McKissick Jr.)

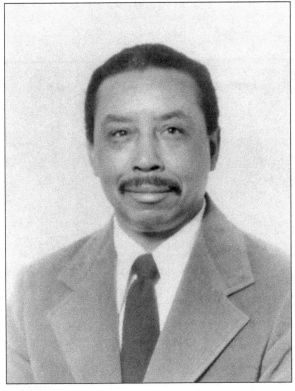

Leroy B. "L.B." Frasier (1910–2004), an executive with North Carolina Mutual Life Insurance, was instrumental in destroying vestiges of segregation in educational facilities. He guided his sons Leroy Jr. and Ralph Kennedy Frasier in suing for admittance into the state's flagship university; through court order, the two were admitted as the first two black undergraduate students at UNC Chapel Hill. (North Carolina Mutual Life Insurance Company.)

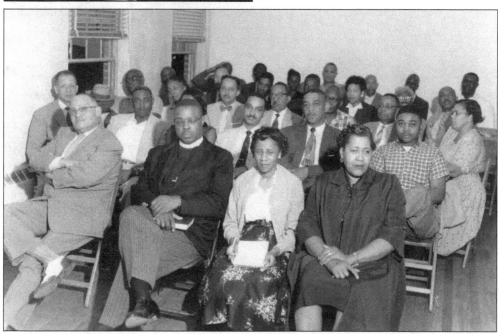

Members of the Durham Committee on Negro Affairs are pictured in the 1950s with a full audience in attendance. At far left in the second row is John H. Wheeler, attorney and president of Mechanics and Farmer Bank, and from left to right in the first row are attorney M. Hugh Thompson, Rev. Reuben Speak, unidentified, and Ellen Warren. (Warren Wheeler.)

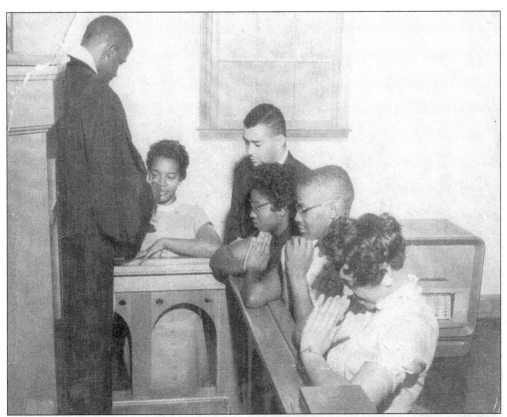

Rev. Douglass Moore, a 29-year-old pastor at Asbury Temple United Methodist Church, prays for members of the Royal Ice Cream Seven before they went to trial for seeking to desegregate on June 23, 1957. The Royal Ice Cream Parlor predated the Woolworth lunch counter sit-in in Greensboro on February 1, 1960. The activists, including Moore, were Mary Clyburn, Virginia Williams, Claude Glenn, Melvin Willis, Vivian Jones, and Jessie Gray. The state erected a historical marker to commemorate the Royal Ice Cream sit-in, and it was dedicated on June 23, 2008, at the intersection of Roxboro and Dowd Streets. (Virginia Williams.)

Deborah George Giles, a native of Durham and a graduate of North Carolina A&T State University, served on the Durham County Board of County Commissioners from 1990 to 1994 and was an advocate for the merger of Durham city and Durham County schools. She serves as director of the Department of Equal Opportunity/Equity Assurance for the City of Durham. (Deborah G. Giles.)

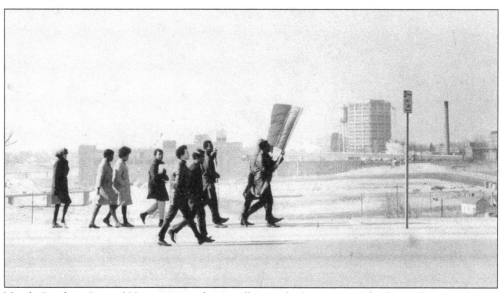

North Carolina Central University students walk over the Interstate-47 bridge as they march into downtown Durham in the 1960s to participate in demonstrations. (*Carolina Times*.)

The ever elegantly dressed Bessie Eaton "Mother" McLaurin (1895–1995) is pictured at her residence on Fayetteville Street. She was born in the Gorman section of Durham County as one of eight children to Richard and Lavenia Goss Eaton. She was active in the civil rights movement in Durham and often opened her home to young civil rights activists, housing countless visiting civil rights leaders in her home. She was a veteran elementary school teacher in the Durham schools who encouraged students to strive for excellence. (Andre D. Vann.)

Attorney Clarence C. "Buddy" Malone (1928–2001) opened his first law office at 336 Pettigrew Street on October 1, 1961. Durham was in the midst of sit-in demonstrations, and Malone was asked by the NAACP Legal Defense Fund and CORE to defend hundreds of cases that spanned from Greensboro to Fayetteville to Elizabeth City. He represented over 500 cases involving student demonstrators and earned the nickname "the Defender." Malone trained an entire generation of lawyers before he retired in 1999. (Vivian McCoy.)

Benjamin S. "Ben" Ruffin (1941–2006) was a native of Durham. In 1989, he was named vice president of corporate affairs at R.J. Reynolds Tobacco Company, a post he held until retirement. In 1998, he served as the first African American chairman of the UNC board of governors. (Avon Ruffin.)

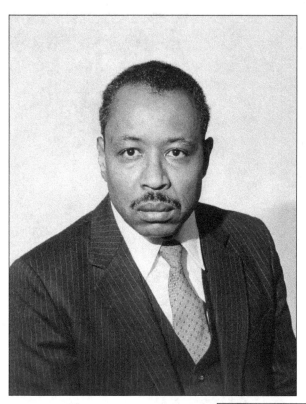

Willie C. Lovett (1939–1992), a graduate of Tennessee State University, came to Durham in 1966 as an industrial engineer with the IBM corporation and retired in 1992. He served as chairman of the Durham Committee on the Affairs of Black People from 1980 to 1990, where he championed equality and inclusion of blacks on boards, commissions, and budgetary appropriations. Under his leadership, the organization consolidated black political power, which resulted in black majorities throughout Durham's city council and county commissioners, representation in the North Carolina General Assembly, various judgeships, and Durham's first black mayor in 1989. Lovett was elected to the 23rd District, North Carolina General Assembly, but died before taking office. He was a veteran of the US Air Force. (Tracy Lovett.)

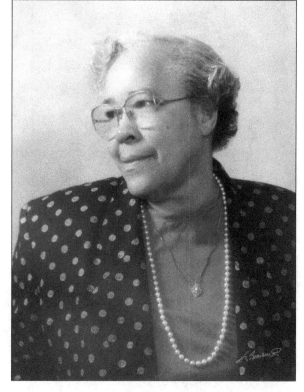

Alma Glenn Steele (1917–1996) was born in Rougemont and educated in the Durham County schools. She was the founder of the McDougald Terrace Residents Council and served with the Boy Scouts of America. Steele was a member and advocate for residents living in public housing, as she served on the Durham Housing Authority Board for 17 years. She was also a founding member of the City Wide Community Council. In 1993, the City of Durham named the Preiss and Steele Place Housing and Apartments for the Elderly and Disabled for her. She was an active member of St. John's Missionary Baptist Church. (Marion Glenn Miles.)

Congressman Melvin L. "Mel" Watt was one of two African American members elected to Congress from North Carolina in the 20th century. He is a Phi Beta Kappa graduate of UNC Chapel Hill and holds a law degree from Yale University Law School. In 1992, he was elected to the newly created 12th District that stretched from Gastonia to Durham and was heavily African American in population. In 1993, the original district was invalidated in the Shaw v. Reno case, and the district was reconfigured to exclude Durham. Watt served as congressman from the 12th District from 1993 to 2014. (Tracy Lovett.)

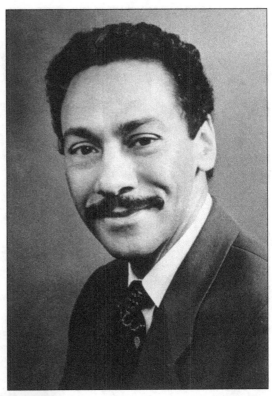

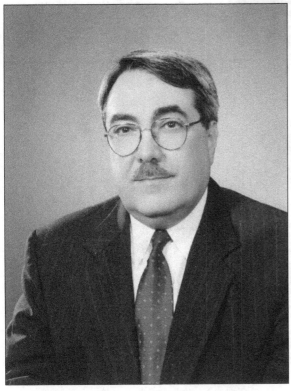

Congressman George Kenneth "G.K." Butterfield is a native of Wilson, North Carolina, and received both his undergraduate and law degrees from North Carolina Central University. As a student, he was active in organizing voter registration drives to demonstrate the importance of the ballot. He practiced law in Wilson and later served as resident superior court judge, which was followed as a member of the North Carolina Supreme Court. In 2004, he was elected to serve the First District of North Carolina in the US House of Representatives and continues to serve this district, which includes Durham. He is a US Army veteran and past chairman of the Congressional Black Caucus. (Congressman G.K. Butterfield.)

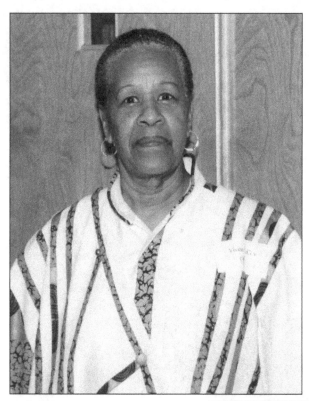

Vivian McCoy has been a civil and human rights and community advocate in the Durham community for over 50 years. In 1957, McCoy was a member of the NAACP Youth Commandos created by attorney Floyd B. McKissick Sr., who led student activists, mostly from Durham, throughout the state, training local activists in nonviolent and direct action protests. During the civil rights movement, McCoy was jailed as a direct result of her actions in the fight for civil rights. She picketed the Royal Ice Cream Parlor in Durham and Durham's Howard Johnson's restaurant. (Vivian McCoy.)

Mayor William Vaughn "Bill" Bell, a native of Winston Salem, graduated from Howard University and New York University with degrees in electrical engineering. He served as a member of the Durham County Board of County Commissioners from 1972 to 1994. From 1982 to 1994, he served as the first African American chairman of the county board. He was a leader in the merger of the Durham city and county school systems—now Durham Public Schools. He was reelected from 1996 to 2000. Bell has served as mayor of Durham for 16 years, from 2001 to the present, and was the second African American to achieve this distinction. He retired as senior engineer from the IBM corporation in 1996 and has been an executive with UDI Community Development Corporation since 1996. (Mayor William V. "Bill" Bell.)

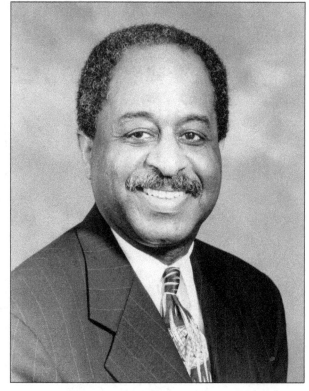

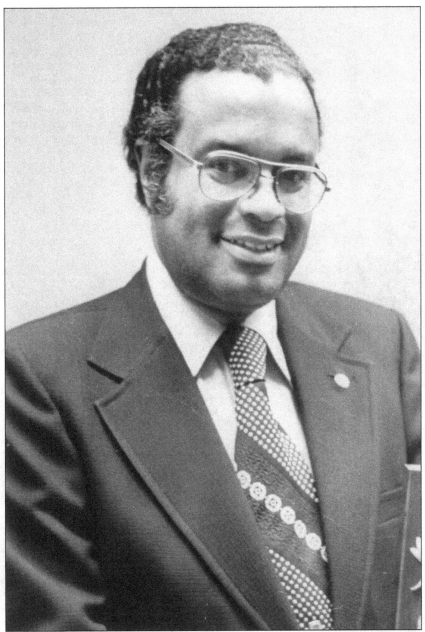

Arthur John "A.J." Howard Clement III came to Durham in 1961 as a third-generation employee of the North Carolina Mutual Life Insurance Company. He took part in the 1963 March on Washington, and upon the death of Dr. Martin Luther King Jr. in 1968, was an organizer and first chair of the Black Solidarity Committee for Community Improvement. The organization led to the creation of the first Durham Human Relations Commission, which sought better housing, employment, and educational opportunities for African American residents. Clement led the boycotts and participated in the demonstrations to desegregate Durham's businesses. He was appointed to the Durham City Council in 1983 but stepped down in 2013 due to ill health. He was a steady presence at various meetings, programs, and events in the life of the city and county of Durham. (North Carolina Mutual Life Insurance Company.)

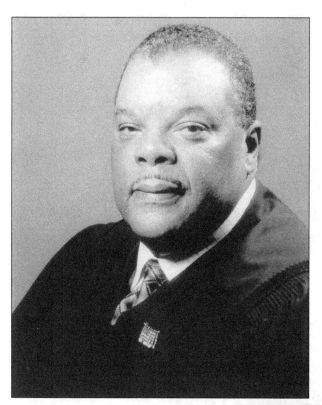

Judge A. Leon Stanback, a native of Hillsborough and graduate of North Carolina Central University, was appointed a superior court judge in 1989 and served until 2009. He later served as interim district attorney for the 14th Judicial District from 2012 to 2014. (Judge A. Leon Stanback.)

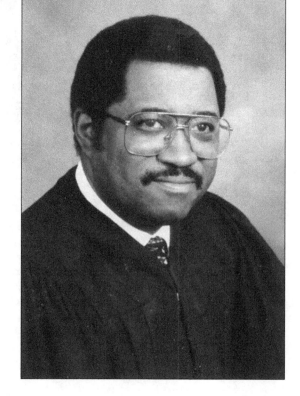

Judge Orlando F. Hudson is the senior resident superior court judge for the 14th Judicial District, serving Durham County. He was on the bench from 1989 until 1995, when he became senior resident judge. (Judge Orlando F. Hudson.)

Seven

Symbols of Progress

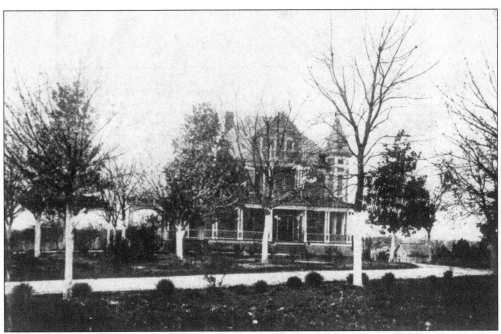

The Maples, located at 406 W. Wilkerson Avenue at the north end of Gattis Street in the West End of Durham, was the home of noted brick manufacturer Richard B. Fitzgerald and Sarah Ann Fitzgerald. The impressive home was built in 1890 and demolished in the 1930s after a fire; the land was later purchased by Duke University. (Durham Photographic Archives.)

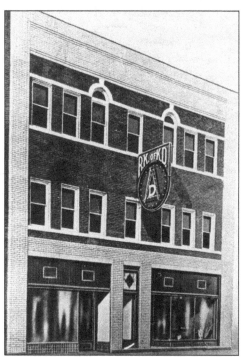

The Royal Knights of King David building, located at 702–704 Fayetteville Street, housed the administrative offices of the fraternal organization, but it also was used as a dance hall for neighborhood groups. The structure later housed Fuller Products Cosmetics and the Garrett Parker drugstore.

The old John Avery Boys Club (and later YWCA) building on Fayetteville Street was the first structure to be officially razed as a project of the Durham urban renewal that removed over 120 African American–owned businesses and over 500 families that were displaced in the Hayti-Elizabeth Street project. (North Carolina Mutual Life Insurance Company.)

John Moses Avery (1876–1931), namesake of the John Avery Boys and Girls Club, was an executive with the North Carolina Mutual Life Insurance Company and was dedicated to the religious, business, educational, and interracial uplift of the African American community in Durham. (North Carolina Mutual Life Insurance Company.)

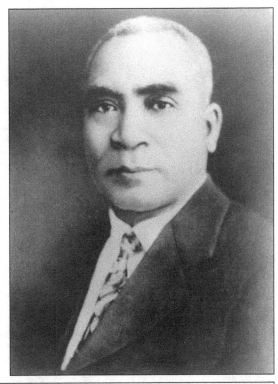

A young lady is pictured in the 1940s standing in front of the Jones Hotel, which dates to the 1900s and was owned by Josie L. Jones. The two-story hotel, located in the Hayti community at 502 Ramsey Street, had a double veranda and was made of brick. (Durham Historic Photographic Archives.)

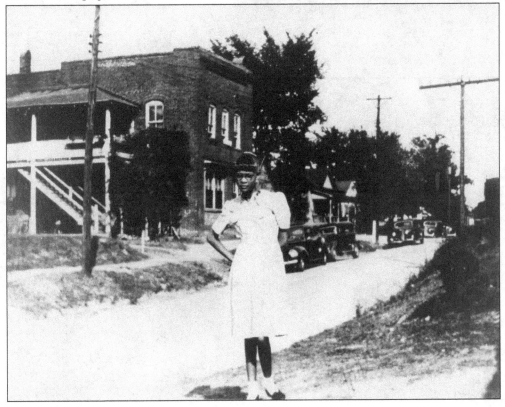

This 1920s view of downtown Durham shows an arrow pointing to the six-story home office building of the North Carolina Mutual Life Insurance Company that was dedicated on December 17, 1921. The structure was an anchor for Black Wall Street–Parrish Street and is a National Historic Landmark. (North Carolina Mutual Life Insurance Company.)

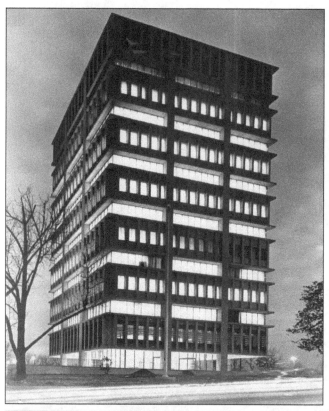

This rare and iconic photograph taken at night captures the North Carolina Mutual Life Insurance Building, located at Mutual Plaza on the site of the former home of Benjamin N. Duke's estate Four Acres. The $4.5 million structure was dedicated on April 2, 1966, and is currently known as Legacy Place. (North Carolina Mutual Life Insurance Company.)

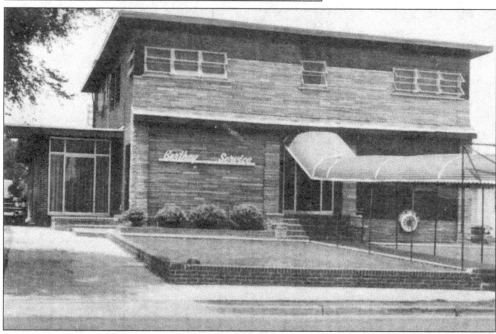

The Burthey Funeral Home, located on Fayetteville Street, was founded by Grover C. Burthey Sr. and his firm Burthey Bros. Funeral Service. It was established in 1946 at 1510 Fayetteville Street, and is seen here in 1965. (Andre D. Vann.)

The Scarborough & Hargett Funeral Home, which was formerly located at 306 S. Roxboro Street, sat on two and a half acres and served as the fourth location for the funeral home, which was dedicated on February 6, 1974, at a cost of $215,000. The structure was razed to make way for the new Durham County Justice Center. (J.C. Scarborough III.)

The Fenton H. and Roxie A. Holloway Rowland brick home, located on Fayetteville Street, was representative of homes built in the College View section of Durham near North Carolina Central University. The gardens at the home offered seasonal beauty year-round and attracted the attention of numerous visitors. (Andre D. Vann.)

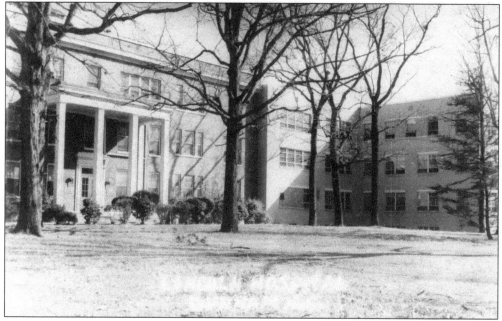

Lincoln Hospital was founded in 1901 through the urging of John Merrick, Dr. Aaron Moore, and Dr. Stanford L. Warren, who petitioned Washington Duke and his sons James B. and Benjamin N. Duke to provide a suitable medical facility for African Americans in Durham and the surrounding community. (Andre D. Vann.)

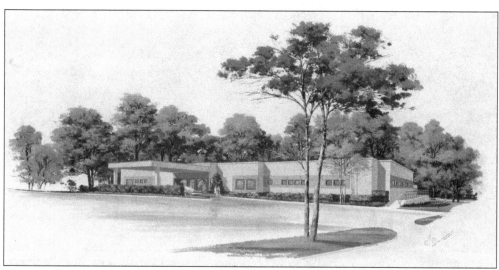

The Lincoln Community Health Center, located at 1301 Fayetteville Street, was founded by Dr. Charles D. Watts and has provided a multifaceted approach to pediatric, adolescent, adult medicine, family medicine, dental, and behavioral health services since 1971. (*Carolina Times.*)

Eight

CIVIC AND SOCIAL LIFE AND THE ARTS

This c. 1935 photograph shows young students who are members of the East End Thrift Club. (*Carolina Times.*)

Members of the Durham Shriners Consistory No. 218 are pictured at a dinner in the 1950s. James F. Pratt (1887–1974), second from the left, served as a Mason leader for over 40 years and was deputy oasis of the Durham Shriners Consistory No. 218. Fourth from the right is Adeline Reynolds Spaulding (1916–2008), who served as illustrious commandress of Zafa Court No. 41 and as imperial deputy of the oasis (Durham). (Andre D. Vann.)

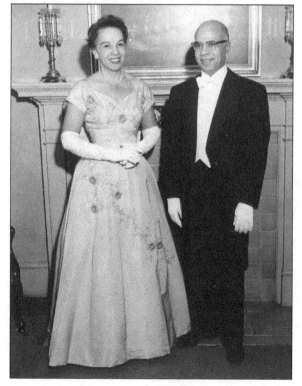

Elna B. and Asa T. Spaulding Sr. are seen in formal attire in their home on Lincoln Street in the 1960s. They both provided leadership to numerous civic, religious, and educational organizations in Durham and the state of North Carolina. (North Carolina Mutual Life Insurance Company.)

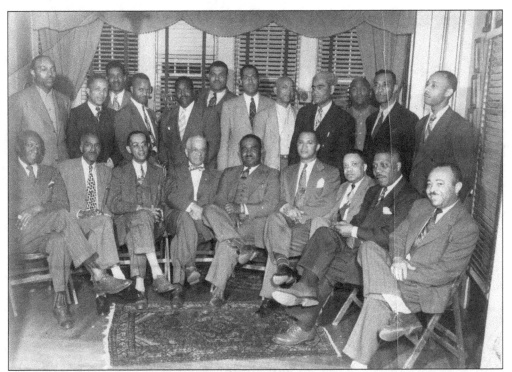

Members of the Durham Alumni Chapter of Kappa Alpha Psi are pictured around the late 1940s. (Andre D. Vann.)

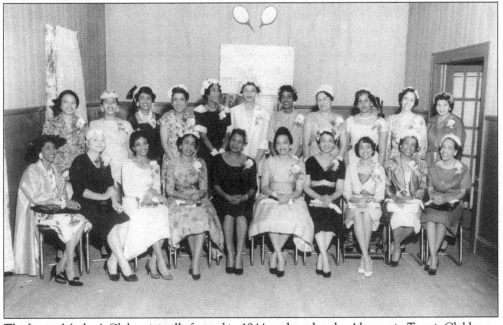

The Junior Mother's Club, originally formed in 1944, gathered at the Algonquin Tennis Clubhouse on Fayetteville Street on April 12, 1959, to pay tribute to Bessie A.J. Whitted. The club is a member of the North Carolina Federation of Negro Women's Clubs and is still in existence. (Maggie Poole Bryant.)

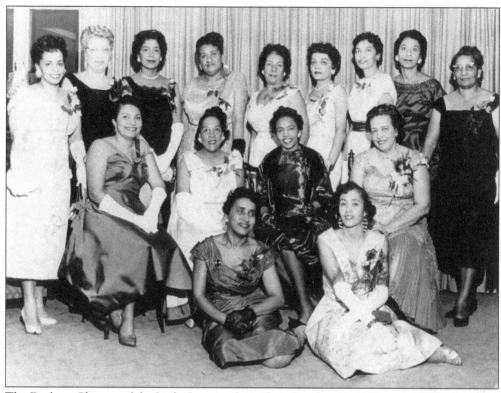

The Durham Chapter of the Links Inc. was formed on October 11, 1958, as the 77th chapter of the national body. Charter members are, from left to right, (on the floor) Fannie Robinson and Constance Watts (seated) Julia Dawson, Barbara Cooke, Ophelia Grandy, and Dessa Turner (first president); (standing) Mae B. Spaulding, Mollie Lee, Josephine D. Clement, Dr. Helen G. Edmonds, Otelia S. Stewart, Hazel Rivera, Lola Riddick, Selena W. Wheeler, and Frances Eagleson. Not pictured is Rebecca P. Edmonds. (Warren Wheeler.)

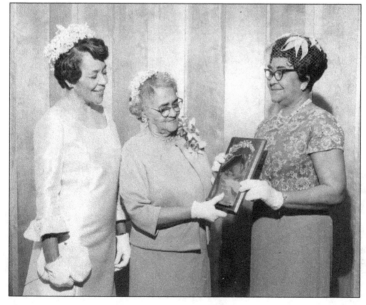

The Durham Chapter of the Links Inc. honored Lyda Moore Merrick (center), an accomplished musician, painter, and editor of *Negro Braille Magazine*, on Sunday, April 20, 1969, in a program held in the Alfonso Elder Student Union. Pictured with her are Minnie W. Pearson Turner Spaulding, president of the Durham chapter (left) and Emma L. Randolph, a Links member and mistress of ceremonies. (James M. Turner.)

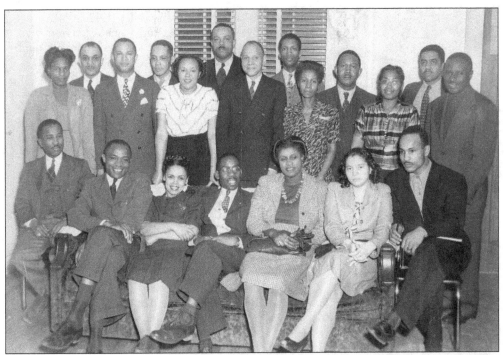

This 1940s photograph shows members of the Durham Chapter of the Hampton Institute Alumni, including R. Kelly Bryant Jr., in the first row at center. (Maggie Poole Bryant.)

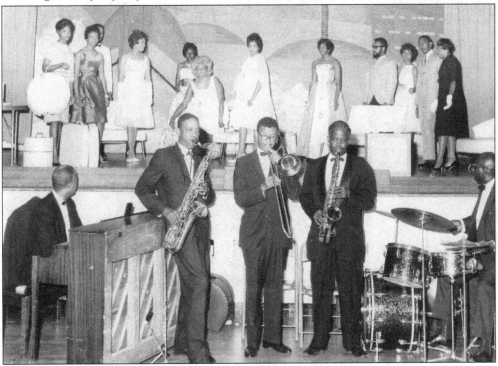

Esther Wiley, a noted beautician, is seated at center on stage in this 1960s photograph, along with participants in an annual fashion show that she conducted yearly for WSRC. (*Carolina Times.*)

Esther Watts Wiley (1912–2014), a beauty culturist, graduated from DeShazor's Beauty System in 1960 and studied at L'Oréal de Paris in Paris, France. She dedicated over 50 years to the beautician profession and was the founder of the annual Trade and Fashion Show held in Durham. (*Carolina Times.*)

Members and officers of the Daughters of Dorcas Club are seen here in the 1990s. The club was founded in September 1917 and originally called the Busy Women's Club. It has provided a number of community service oriented activities in the Durham community and is still in existence. (Janet Young Peeler)

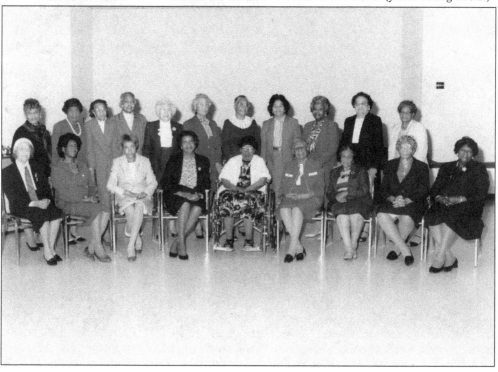

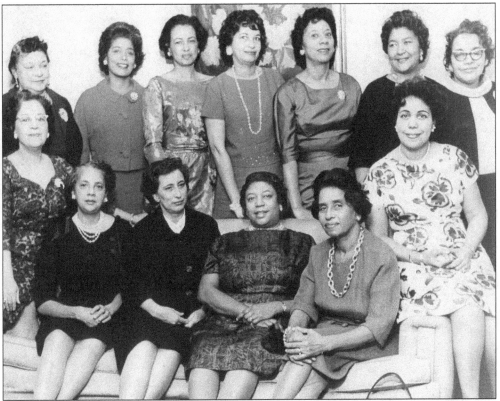

In this group photograph are members of the Merry Wives Bridge Club. They met on Saturday evenings and usually began with a scrumptious meal. (Warren Wheeler.)

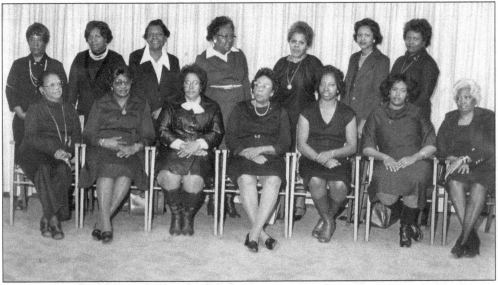

DeShazor Beauty College Alumni Chapter No. 9 members are shown in 1979 after their meeting. From left to right are (seated) Earlie S. Grandy, Mable G. Burnett, Helen Williams, Josephine Perry, Rosena Sherrill, Barbara Bruton, and Esther L. Wiley; (standing) Hattie Geer, Fidelice Brooks, Hazel McKoy, Willie McKeethian, Alice Faye Carmon, and Louise Lyons. (*Carolina Times.*)

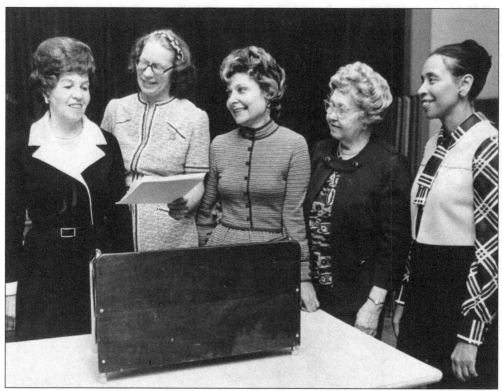

Elna Bridgeforth Spaulding (1909–2007), at far left, was the founder and president of Women-In-Action for the Prevention of Violence and its Causes, an interracial, independent, and nonprofit community service organization founded on September 4, 1968, to improve race relations and stem the tide of racial unrest sweeping throughout Durham and the country. (*Carolina Times*.)

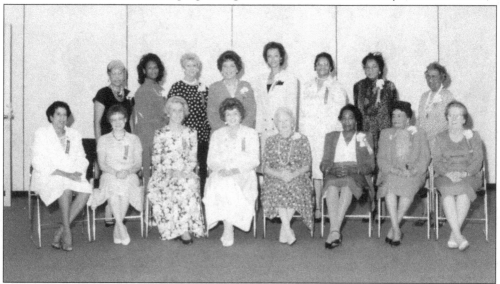

In the early 1990s, honorees and the founder Elna B. Spaulding are pictured at the annual Women-In-Action for the Prevention of Violence and its Causes banquet recognizing interracial community work by women activists in the Durham community. (Andre D. Vann.)

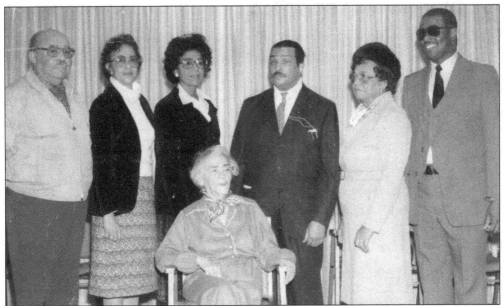

Lyda Moore Merrick (1890–1987), the first editor of *Negro Braille Magazine* (from 1952 to 1968), the first of its kind in the world, is seated at center surrounded by members of the board of the magazine, which later changed its name to *Merrick Washington Magazine for the Blind*. From left to right are F. Frank Burnett, Constance Merrick Watts, Josephine Dobbs Clement, John Washington (the inspiration for the magazine and associate editor), unidentified, and Dr. Marcus Ingram. (Catherine B. Mangum.)

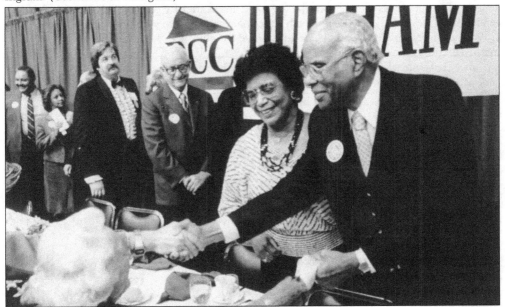

Described as "Durham's First Couple in Service," Josephine Dobbs Clement and William A. "Bill" Clement were the 1986 recipients of the Distinguished Civic Award from the Durham Chamber of Commerce. The couple arrived in Durham in 1946, and after 50 years of service, they returned to Atlanta in 1996, having built a legacy of public service in the Durham community. (Arthur J. Clement.)

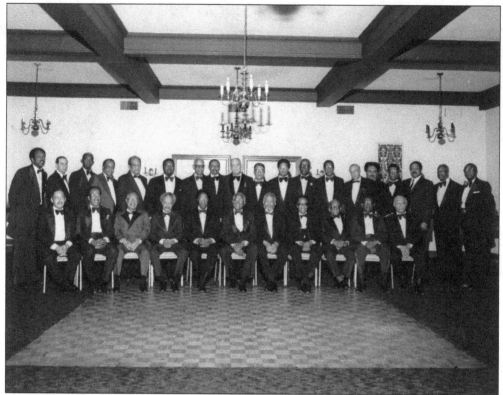

This 1982 image shows members of the Sigma Pi Phi fraternity during their spring initiation ceremony. The Alpha Tau Boule of North Carolina was chartered with nine members on March 2, 1969, at the Statler Hilton Inn in Durham. Under the guidance of Dr. Albert N. Whiting, there were 10 founding archons: Dr. Lionel H. Newsom, Dr. Robert E. Dawson, William A. Clement, Dr. Emery L. Rann, Maceo A. Sloan, Dr. Leonard H. Robinson, Dr. LeRoy T. Walker, Dr. Charles D. Watts, Dr. Charles A. Ray, and John S. Stewart.

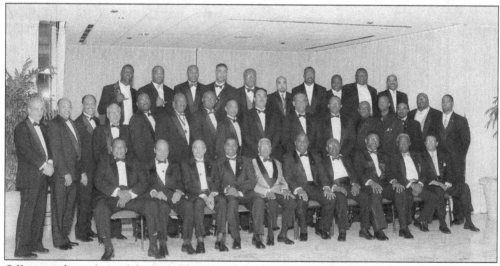

Officers and members of the Beta Theta Lambda chapter of Alpha Phi Alpha fraternity are seen at an annual New Year's Eve ball. (Andre D. Vann.)

Dr. Charles "Chuck" Davis, best known as "Baba Chuck," is founder, choreographer, teacher, and artistic director of the African American Dance Ensemble and the New York–based Dance Africa. The Raleigh, North Carolina, native and US Navy veteran has dedicated over four decades to the preservation and sharing of traditional African and African American dance and music through research, education, performance, and entertainment. Davis founded the African American Dance Ensemble in Durham in 1983, and was named one of America's 100 irreplaceable dance treasures by the Dance Heritage Coalition. (Dr. Charles "Chuck" Davis.)

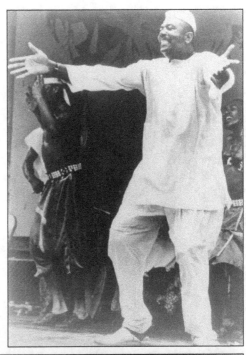

Elizabeth Catlett (1915–2012), a sculptor and printmaker, came to Durham in 1935, which was her mother's hometown, and taught art at Hillside Park High School for two years before departing to attend graduate school in art at the University of Iowa. (Robert Lawson.)

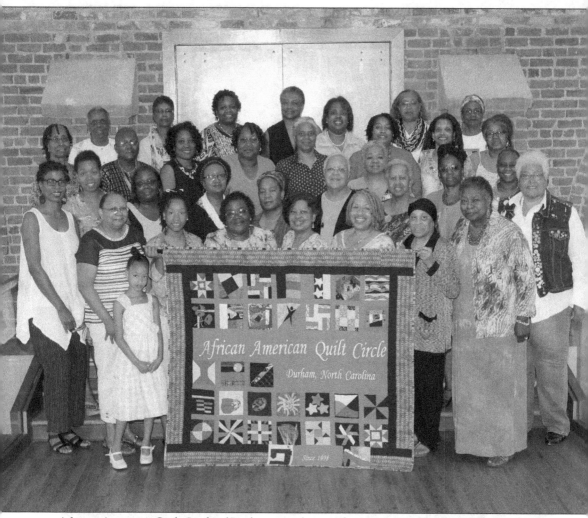

African American Quilt Circle of Durham members are known as the "sisterhood," and the group consists mostly of women who meet at the Hayti Heritage Center once a month to "quilt, talk, laugh, stitch, love and support" one another. The group began in 1998 and has over 80 members with a mission to preserve the tradition of quilting in the African American community. (African American Quilt Circle of Durham/Dr. Jerry Head.)

Nine

AFRICAN AMERICAN MUSIC AND ENTERTAINMENT PIONEERS

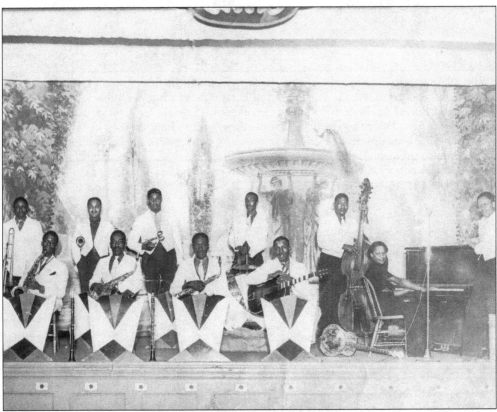

Pictured in the late 1930s in the old Whitted School auditorium are members of the Bull City Night Hawks Dance Orchestra, which was founded by Frank Wright and Wellington Black in 1933. Both Wright and Wellington were former pupils of music "professor" I.H. Buchanan. The group provided music in venues from the 1930s up until 1967, upon the death of Wright. (Everett L. Goldston.)

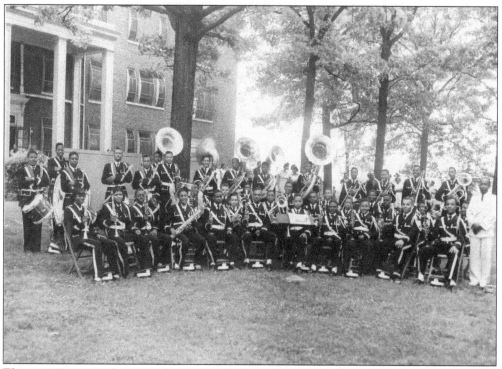

This c. 1950s image shows members of the Hillside Band on the front lawn of Lincoln Hospital in the Hayti section of Durham. In the first row at far right in white is Phillmore "Shorty" Hall, a Tuskegee Institute graduate and a noted trumpeter who taught for 11 years at Hillside High School in Durham, becoming the first African American bandmaster hired in North Carolina. With his most talented students, Hall later created a big band outfit called the Hillside Joymakers that performed throughout the Durham area. In 2002, he was inducted into the North Carolina Bandmasters Association Hall of Fame. (Everett L. Goldston.)

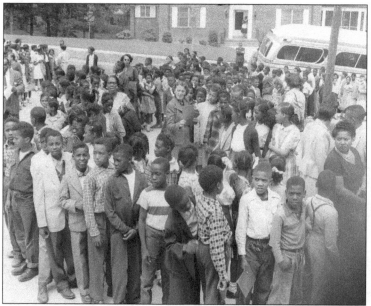

Pictured in 1954 are eager African American Durham public school students along with teachers and parents waiting to enter McDougald Gym on the North Carolina College at Durham campus for the North Carolina Symphony children's concert program spring tour. (Harold W. Alexander.)

A member of the North Carolina Symphony shares readings from a booklet entitled *Symphony Stories* to students during the 1954 children's concert program. (Harold W. Alexander.)

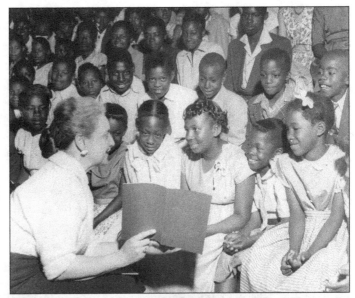

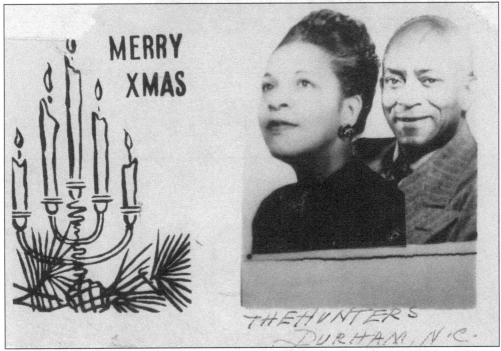

This Christmas postcard greeting from noted vocalist Nell Hunter (1889–1992) and her husband, Dr. A.S. Hunter (1883–1957), was sent to family and friends. Nell Pierce Hunter was born in Memphis, Tennessee, and after marrying Dr. Hunter, lived in Durham for over 40 years where her voice could be heard in churches and community events. She taught school, took voice lessons, and served as national choral director for the National Youth Administration and was invited by Pres. Franklin D. Roosevelt in 1939 to sing at the White House for the king and queen of England. Nell received her master's degree from the Chicago Musical College and later studied in Vienna, Austria. Upon return, she performed many concerts in the United States. After the death of her husband in 1957, she moved to Chicago, Illinois, to be near family. (Andre D. Vann.)

Students are pictured at a piano recital around 1952 in the sanctuary of the White Rock Baptist Church, which served as host for the Annual Chamberlain Studio Piano Recital, presented by Margaret Shearin as a form of musical enrichment for Durham students who received training and inspiration in musical endeavors. (Claudine Daye Lewis.)

This c. 1958 photograph was taken in the sanctuary of White Rock Baptist Church, showing students instructed and directed by Margaret Shearin. Shearin named her studio for her former Fisk University music teacher, Mary E. Chamberlain. Some of Durham's most talented musicians received training and instruction under Shearin. (Claudine Daye Lewis.)

On October 15, 1980, in recognition of her 55th anniversary Margaret Spaulding Shearin (1901–1989), left, received recognition for her work in fostering music. A native of Durham, she attended the local public schools and began taking piano lessons at age five in 1906, continuing until 1924. She graduated from Fisk University in 1924 and returned to Durham to teach. She taught piano and directed the chorus at Durham State Normal School until 1925, when she founded the Chamberlin Studio and taught piano lessons until 1986. Shearin nurtured countless students in Durham and the surrounding areas. (Marsha Goodwin Kee.)

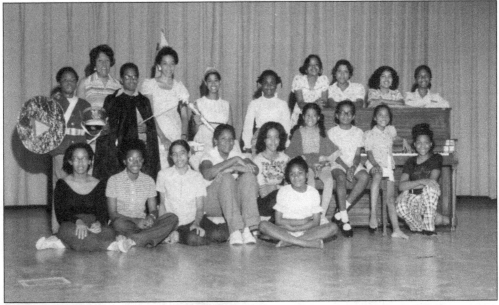

Barbara Logan Cooke (1921–) is pictured with students in her private studio at Christmas 1974. Cooke moved to Durham at age five and received her academic training at Fisk University and the Julliard School of Music. She taught piano at Hampton Institute (1943–1946), and since 1955 has taught music appreciation at both North Carolina Central University and in her private studio. She is a specialist in arranging negro spirituals for voice and solo instruments and is also known for dramatic performances. She has performed with the Durham Community Players and with the North Carolina Central University Drama Group. She has also served as a master teacher and has trained numerous students in music in her home on Lawson Street. (Barbara Logan Cooke.)

Dr. Joseph T. Mitchell has served as a high school and university bandleader and church choir director for over 70 years. He served as band director at North Carolina Central University from 1967 to 1972. (Dr. Jerry Head.)

Dr. Charles H. Gilchrist (1939–1996), a professor, composer, and choral director, served as a professor in the music department and director of choral activities at North Carolina Central University. He was a native of Laurinburg, North Carolina, and received his bachelor's degree in music from North Carolina College (now North Carolina Central University) in 1961, where he was president and assistant director of the choir. In 1980, he received a doctor of education degree from UNC at Greensboro. He produced three albums and published several arrangements, and in 1975, Pres. Gerald R. Ford recognized his performance of the choir during his visit to the campus. Gilchrist served for 25 years as a music professor at North Carolina Central University. He directed 28 annual spring tours, which brought national recognition to the university. He served as a guest conductor, lecturer, and clinician for high school, college, and university choruses. He attended St. Joseph AME Church, where he was director of the senior choir and minister of music from 1973 to 1975 and 1977 to 1996. (Iris W. Gilchrist.)

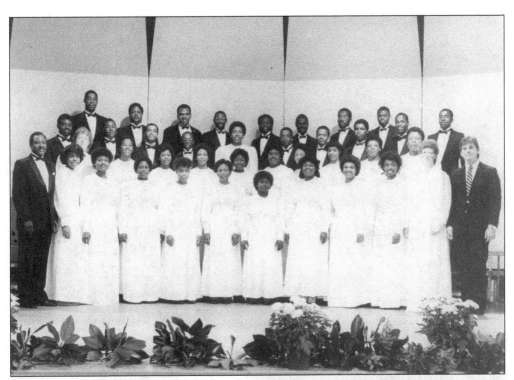

Dr. Charles H. Gilchrist (first row, far left) is shown with members of the NCCU Touring Choir, who performed on campus and across the United States. (Iris W. Gilchrist.)

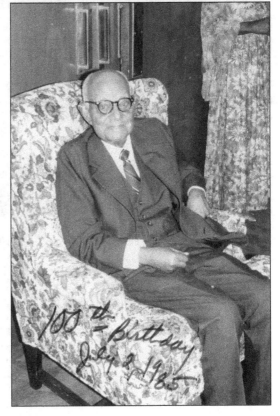

Charles Jacob Harris (1885–1988), a native of Augusta, Georgia, graduated from Paine College in 1904 and studied at the New England Conservatory of Music, where he met the famed tenor Roland Hayes. In 1922, he married Durham native Eleta Atwater, an employee at North Carolina Mutual Life Insurance Company. He would later serve as accompanist to Hayes, who trained him in voice building and interpretation. Harris pursued a teaching career that lasted 50 years and included colleges in Tennessee, Alabama, Mississippi, and Maryland, with his longest tenure at South Carolina State College. Upon retirement, he returned to Durham and served on the music faculty at North Carolina Central University. He played classical and ragtime compositions for senior citizen groups in Durham from 1978 until 1985, at age 100. (Pat Murray.)

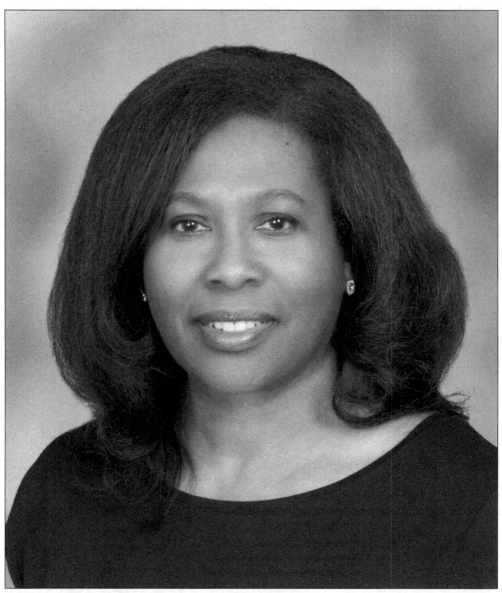

Dr. Paula Harrell, retired music professor and organist, has served as a member of the Music Ministry at White Rock Baptist Church since the 1960s. She became interested in music at the age of four. A native of Durham and graduate of NCCU in 1976, she became the first student in the history of the music department to give two honors recitals. Prior to joining NCCU, she taught general music in elementary school and was a piano instructor at North Carolina A&T State University. She has served as minister of music, organist, pianist, and director of men's senior (chancel), Women's Day, Mass (Inspirational Voices), and the Hand Bells Choir. She also served as an instructor at White Rock Baptist Church. Dr. Harrell retired as chair of the Department of Music at North Carolina Central University and served as university organist for commencement exercises, services of remembrance, and other university programs. She was coordinator/instructor of the Sacred Music program. She served the department as accompanist for student and faculty recitals and the University Choir and taught piano and organ as well as directed the NCCU hand bell ensemble. (Dr. Paula Harrell.)

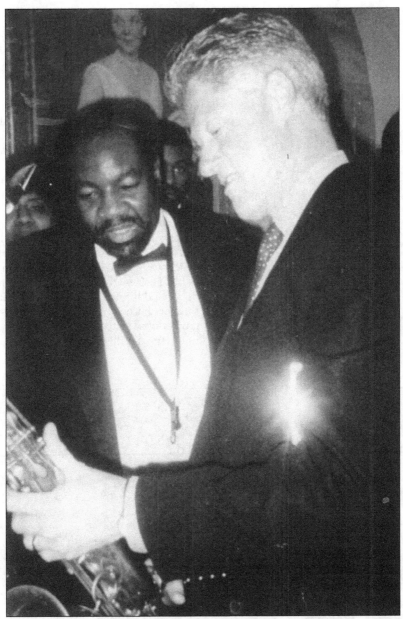

Dr. Ira T. Wiggins, director of Jazz Studies at NCCU and a nationally known saxophonist and flutist, is shown in 1997 with Pres. Bill Clinton as Wiggins's jazz group performed at the White House. A Kinston, North Carolina, native, he received a set of drums from his parents at age five and was largely self-taught until attending North Carolina Central University, where he majored in music and received his formal training. Under his leadership, the program consists of three big bands, a vocal jazz ensemble, four small combos, and a guitar ensemble. He is the founder of the Ira Wiggins Quartet and has 15 albums to his credit. Wiggins, a nationally known musician and educator, has brought national and international acclaim to the Jazz Studies program, where he and his students have performed at the Montreux Jazz Festival in Switzerland (1996 and 1999), the Newport Jazz Festival (2009), and the New York Jazz Festival at Lincoln Center (2010). (Dr. Ira T. Wiggins.)

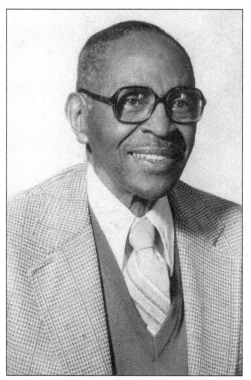

Lathrop Warren "Lath" Alston (1902–1987), a legendary big band music promoter and entrepreneur, was born and educated in Durham, graduated from the Durham State Normal School (now NCCU), and began a career in the early 1920s promoting dances at the Royal Knights of King David Hall on Fayetteville Street. He was successful in bringing such musical giants as Cab Calloway, Duke Ellington, Earl Hines, Guy Lombardo, Fats Domino, and Les Brown to perform. Later, larger venues were used, such as the Durham Armory and Durham's large tobacco warehouses, including the "Big Four," or Roycroft, that was advertised for black dancers and white spectators. Alston later was named manager of the Biltmore Hotel, which was able to house such performers as Ella Fitzgerald, Nat "King" Cole, the Ink Spots, and Ike and Tina Turner. When the Biltmore burned in 1977, all of the historic promotional materials were destroyed in the fire. (William A. Marsh III.)

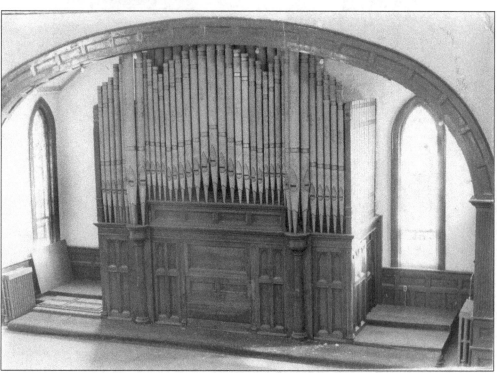

This late 1980s image centers on the platform and organ pipes of the old St. Joseph AME Church sanctuary, located on Fayetteville Street; it has been preserved. (Hayti Heritage Center.)

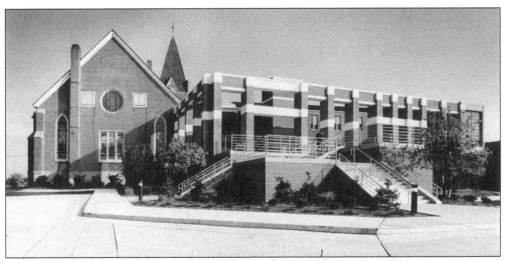

The Hayti Heritage Center opened on September 8, 1991, and is operated by the St. Joseph Historic Foundation, a not-for-profit agency of civic, church, and community members that dates to August 1975, to preserve and promote the Old St. Joseph church to promote programs and services in the facility. The structure is a national historic landmark. In 1998, the foundation received funding for the completion of the restoration of St. Joseph from a city bond referendum and the Doris Duke Foundation, and the sanctuary was completed four years later for a total of $3 million. The architect was the Freelon Group of Durham. The 350-seat St. Joseph Performance Hall and the Lyda Moore Merrick Gallery have been community resources for numerous events and programs, including the annual Bull Durham Blues Festival. (Hayti Heritage Center.)

Carlton Glenn Miles (1963–2009) taught for several years at Hillside High School and was the director of Spotlight, a Durham County public school combined choral group. He was a well-known drummer and accompanist to numerous religious groups and mentor to youth in Durham interested in the vocal and musician fields of study. (Marion G. Miles.)

Discover Thousands of Local History Books
Featuring Millions of Vintage Images

Arcadia Publishing, the leading local history publisher in the United States, is committed to making history accessible and meaningful through publishing books that celebrate and preserve the heritage of America's people and places.

Find more books like this at
www.arcadiapublishing.com

Search for your hometown history, your old stomping grounds, and even your favorite sports team.

Printed in the USA
CPSIA information can be obtained
at www.ICGtesting.com
LVHW010346150923
758078LV00010B/885